stranded

photography and music inspired by the book
Katharina (and other magnificent disasters)

Stranded

Photography and Music inspired by the book
Katharina (and other magnificent disasters)

Copyright 2017 by Jayce Roberts, David Haight, Gary Norman

No part of this book may be reproduced in any form whatsoever, by photography, or xerography, or any other means, by broadcast or transmission, by translation into any kind of language, not by recording electronically or otherwise, without permission, in writing from the authors, except by a reviewer, who may quote brief passages in critical articles or reviews.

ISBN - 13: 978-1544954431
ISBN - 10: 154495443

Book cover, design, layout: Jayce Roberts
All images copyright 2017 Jayce Roberts // Jayce Roberts Images

Source Text from Katharina (and other magnificent disasters)
by David Haight copyright 2017 Will To Power Publishing

24 Frames Publishing

First Printing June 2017

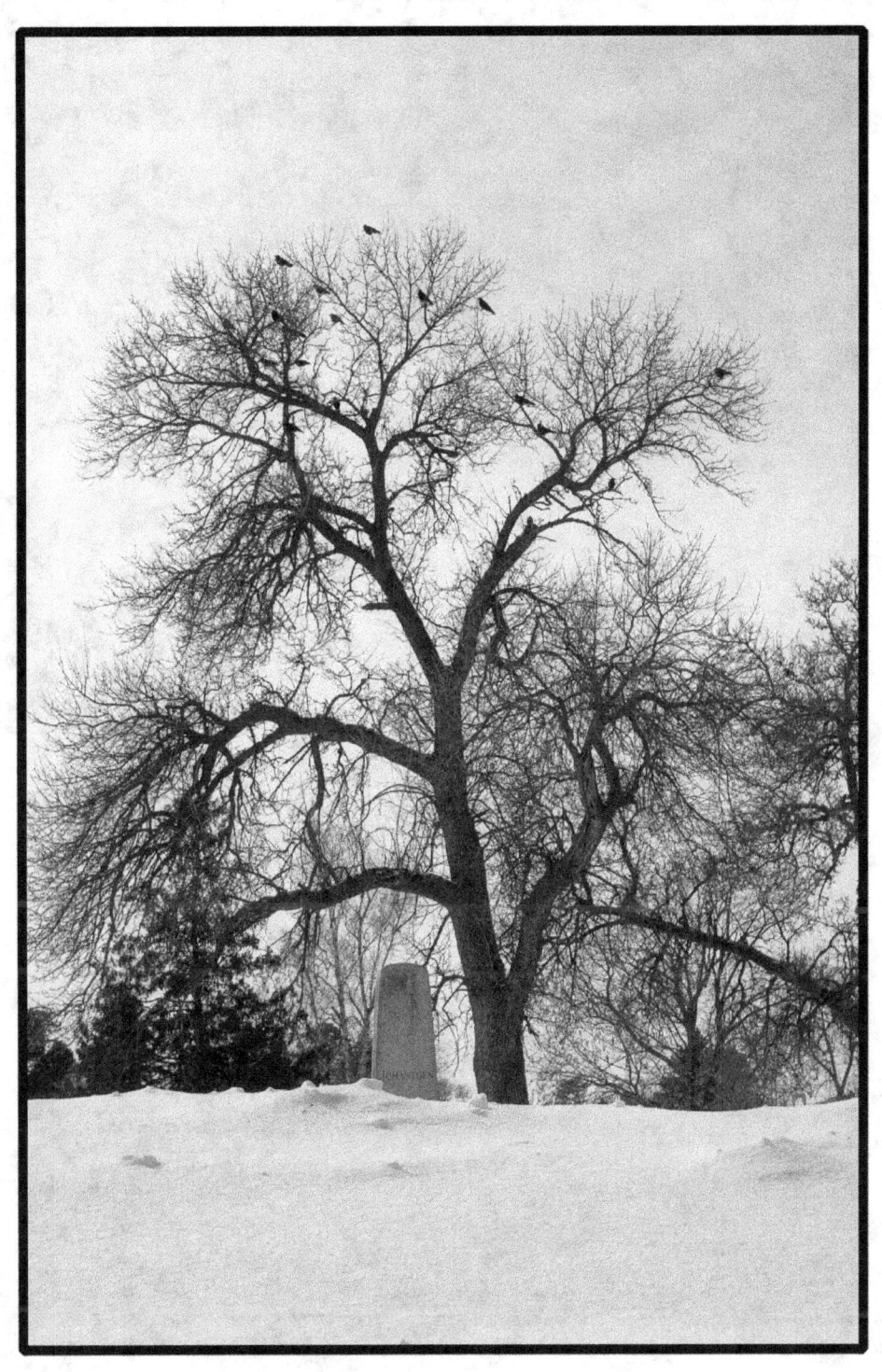

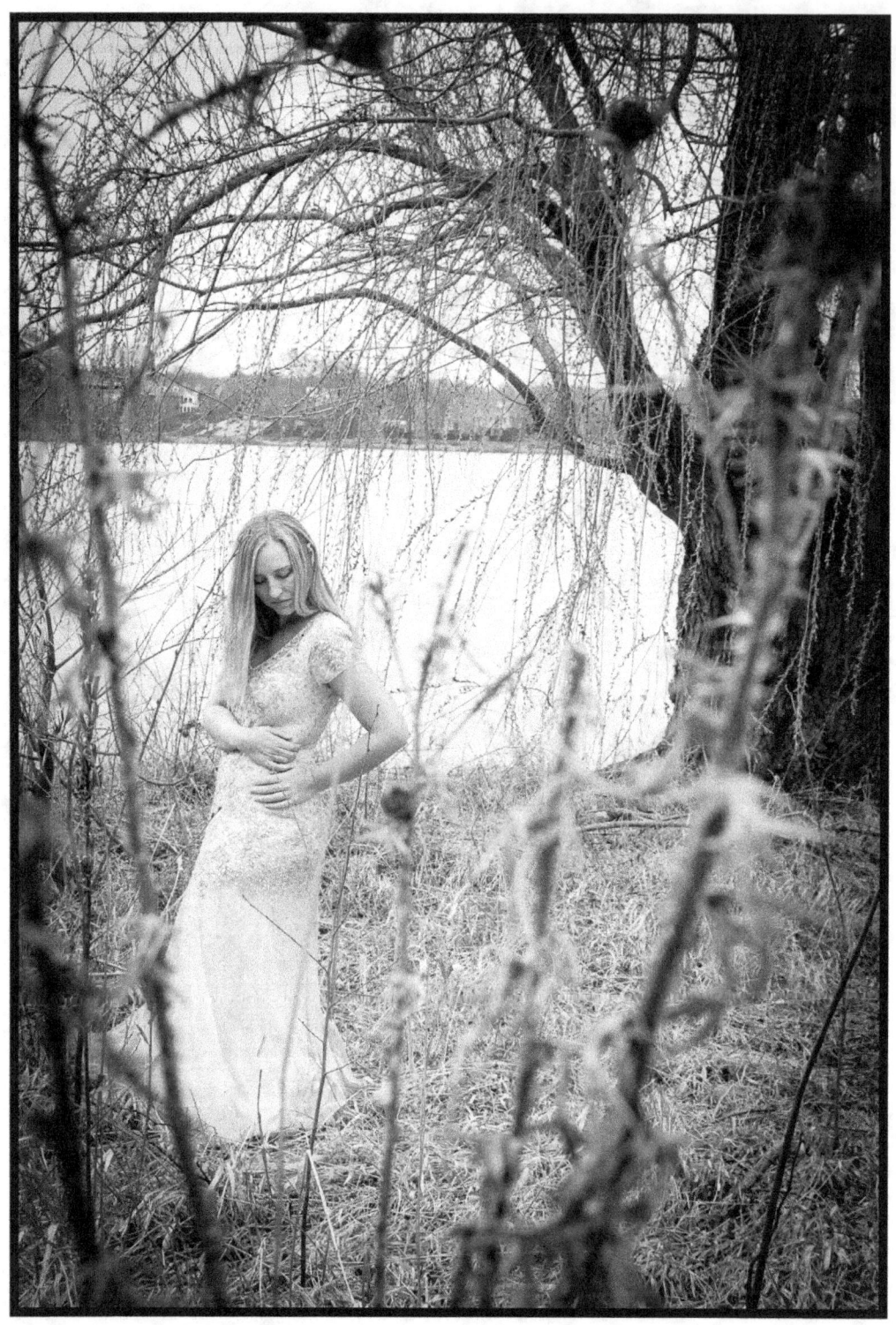

FORWARD

It all started because I was working on my fourth book,
Katharina (and other magnificent disasters) and I needed some feedback.

I gave the manuscript to two of my best friends, musician Gary Norman, and photographer Jayce Roberts. I assumed that after a few weeks of reading they would come back with some constructive criticism having to do with character, story structure, and punctuation that I could use to push the book past the finish line. What I got was something completely unexpected and astounding.

Gary got back to me first, and told me, besides the feedback he had, that he had been inspired to start writing music, playing with the themes and moods presented in the manuscript. Not long after this, Jayce came back with a marked up manuscript telling me the same thing, showing me a series of photographs that he had been inspired to make.

Coming together it was fascinating to see how the music and photographs not only created a dazzling counterpoint to my original text but seemed to be suggesting a completely new narrative by juxtaposing three mediums.
We all agreed we had an entirely new piece.

Now that it is finished it is clear our original impulses were correct.

Stranded: Photography and Music inspired by the book Katharina (and other magnificent disasters) is a stunning example of an artistic conversation by three separate artists, while each of our individual contributions are clear, it is the juxtaposition that creates the transformative effect. In the end, the conversation becomes the piece and vice versa.

We hope you enjoy reading, looking, and listening to this work as much as we did creating it.

David Haight, Katharina (and other magnificent disasters)

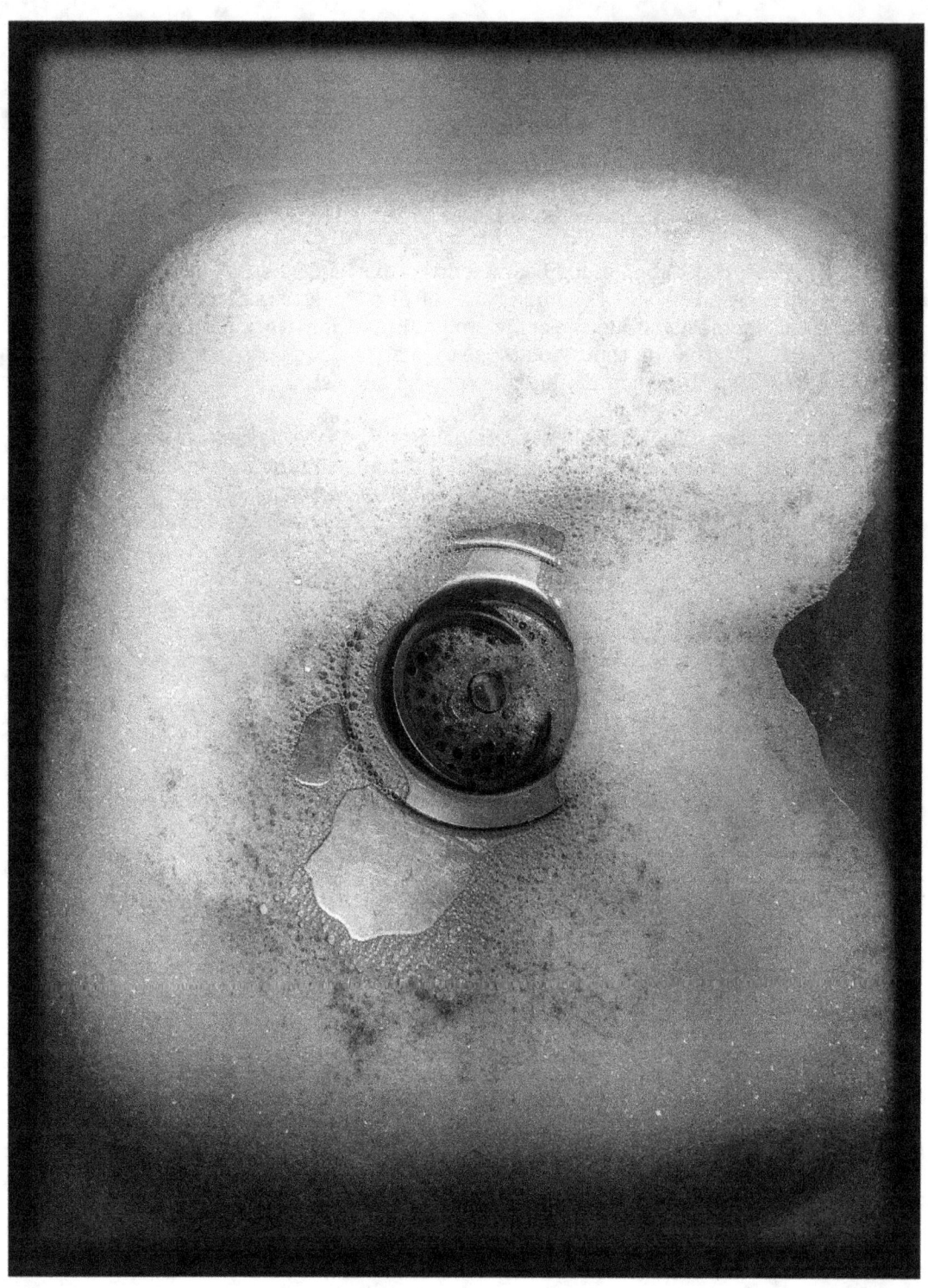

A REASONABLE EXPLANATION (a fragment)

"I already told you, I don't want to talk about her," he said standing up from the couch, sad sacking it into the kitchen hoping a change of venue, no matter how small, would shift the topic of conversation, a topic that had been dominating their life as of late, and if he were honest, since they had met, courted, and married.

"She's threatening to sue you, trying to extort you with those pictures, says she'll call the police if you don't cooperate. For shit that happened years ago that she can't prove," she said following him, taking her usual spot over the sink, hands firm on either side staring into the silver and black hole at it's center.

He closed the refrigerator door, turned around, leaned against it, refused to engage her.

"Well, aren't you going to say anything?"

"You don't know her."

"I'm so tired of hearing about how I don't understand, how she's suffered," she said now facing him. "What about what she put you through? When does that end? When do we get our life, our separate life?"

"I don't know. Never," he said flippantly, reopening and closing the refrigerator door.

"You think this is funny?"

She stared at him hard until he was forced to capitulate. "No."

"I spoke with a lawyer. Nothing will happen. He said it's been too long. If she didn't press charges then, why now? It's too hard to prove, okay? No prosecutor will take the case."

"But don't you see? You had to talk to a lawyer."

"He said not to worry."

"That's not the point."

He knew that.

"She can't let you go, that's all this is," she said. He gazed dumbly at his shoes and the white tile peeking out between them.

"I hate her."

"Yes,"

"I don't know why you don't. She's alienated you from your family, burned friendships, even lost you a job. She's toxic."

He didn't know either.

"Why do you feel bad for her? Because that's the only reason you keep putting up with her shit, keep taking her calls. Can you at least tell me that?"

"She's been through a lot."

No matter what she did to him, to herself or anyone else, no one could ever get him to forsake her. There was no reasonable explanation. It was perverse.

"Quit defending her!" she screamed and stomped off to the bedroom.

The slamming of the door that shook the walls and made the pictures tremble, the tangible manifestation of this woman who would not die.

"I pulled into the Federal Express parking lot at 4:40. The building was a massive cement lung, pumping out gray air from two large smoke stacks and several smaller ones.

As I entered one of the giant bay doors I was terrified that I would never be seen again, terrified that no one would care, or have anything good to say about me, that my funeral would be a series of awkward silences, and relief when it ended and roast beef sandwiches were brought out.

A sense of panic rippled through me, perhaps I didn't have any real belongings, any friends, connections that mattered, perhaps I was not a good man."

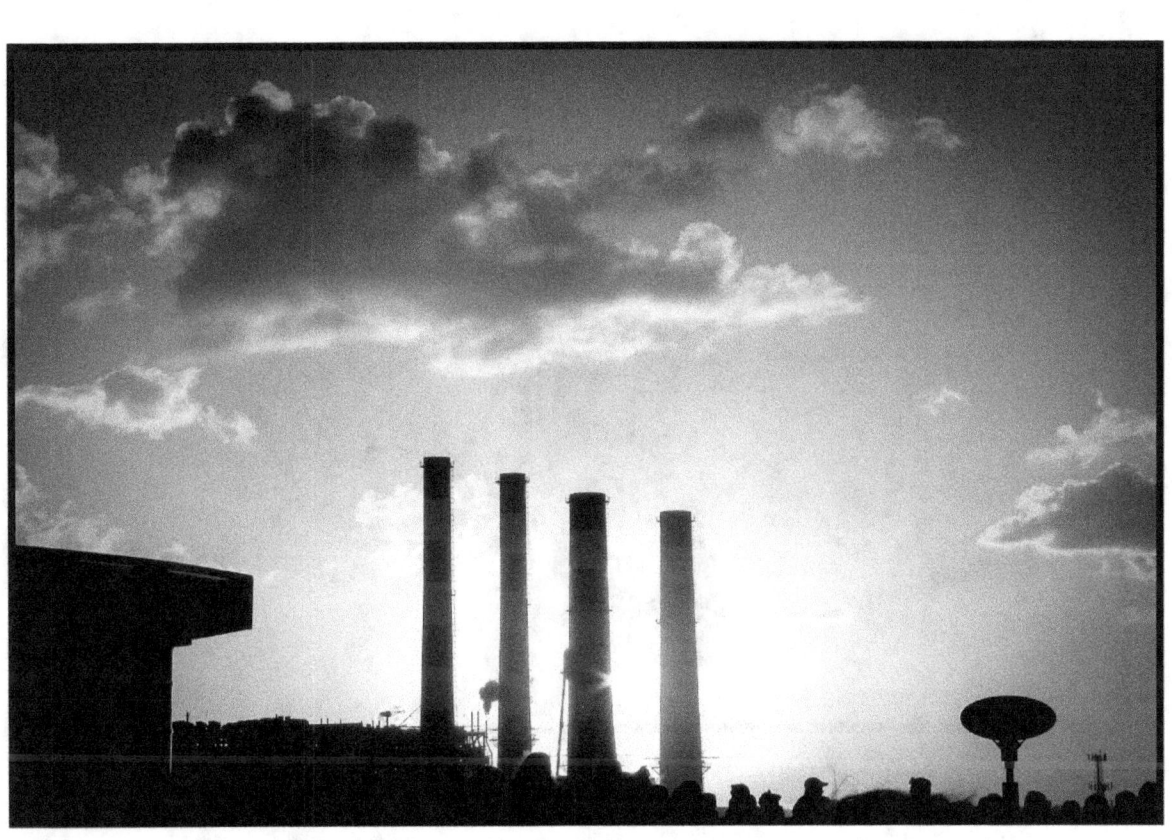

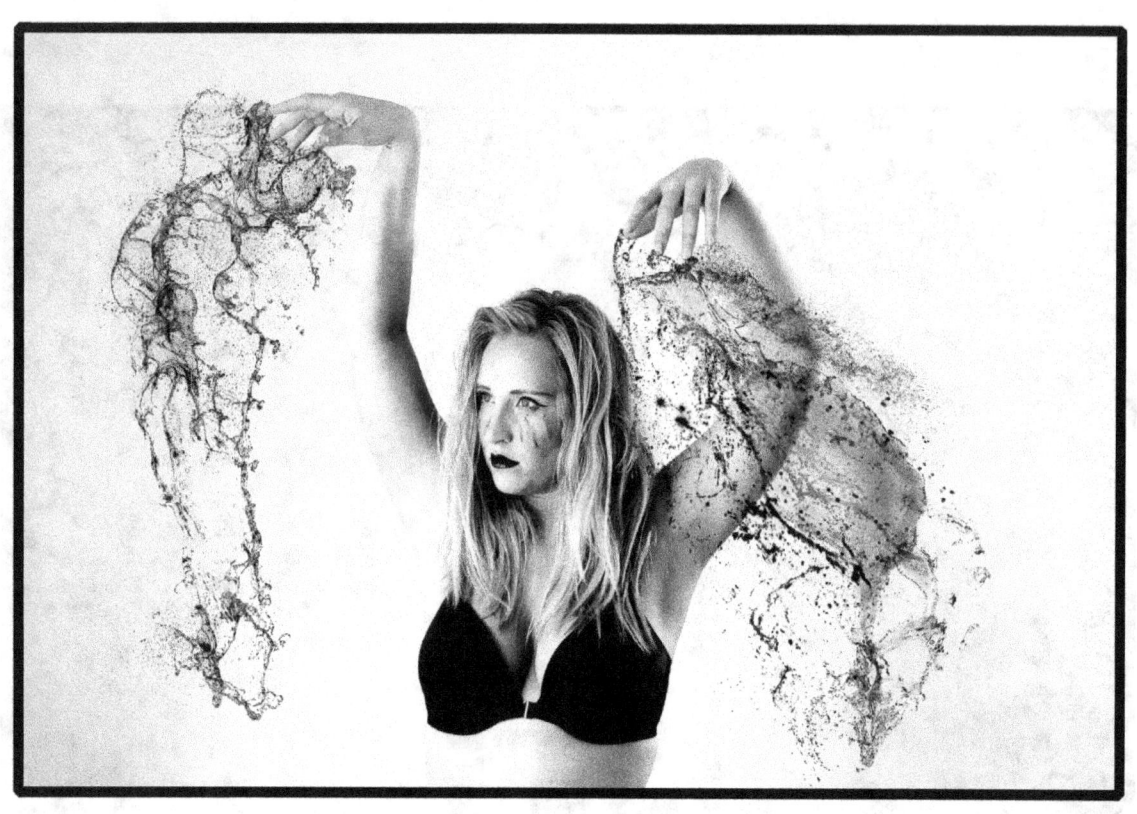

"I didn't have the foresight to know that I would spend my entire life rearranging our life to shake off her chronic dissatisfaction."

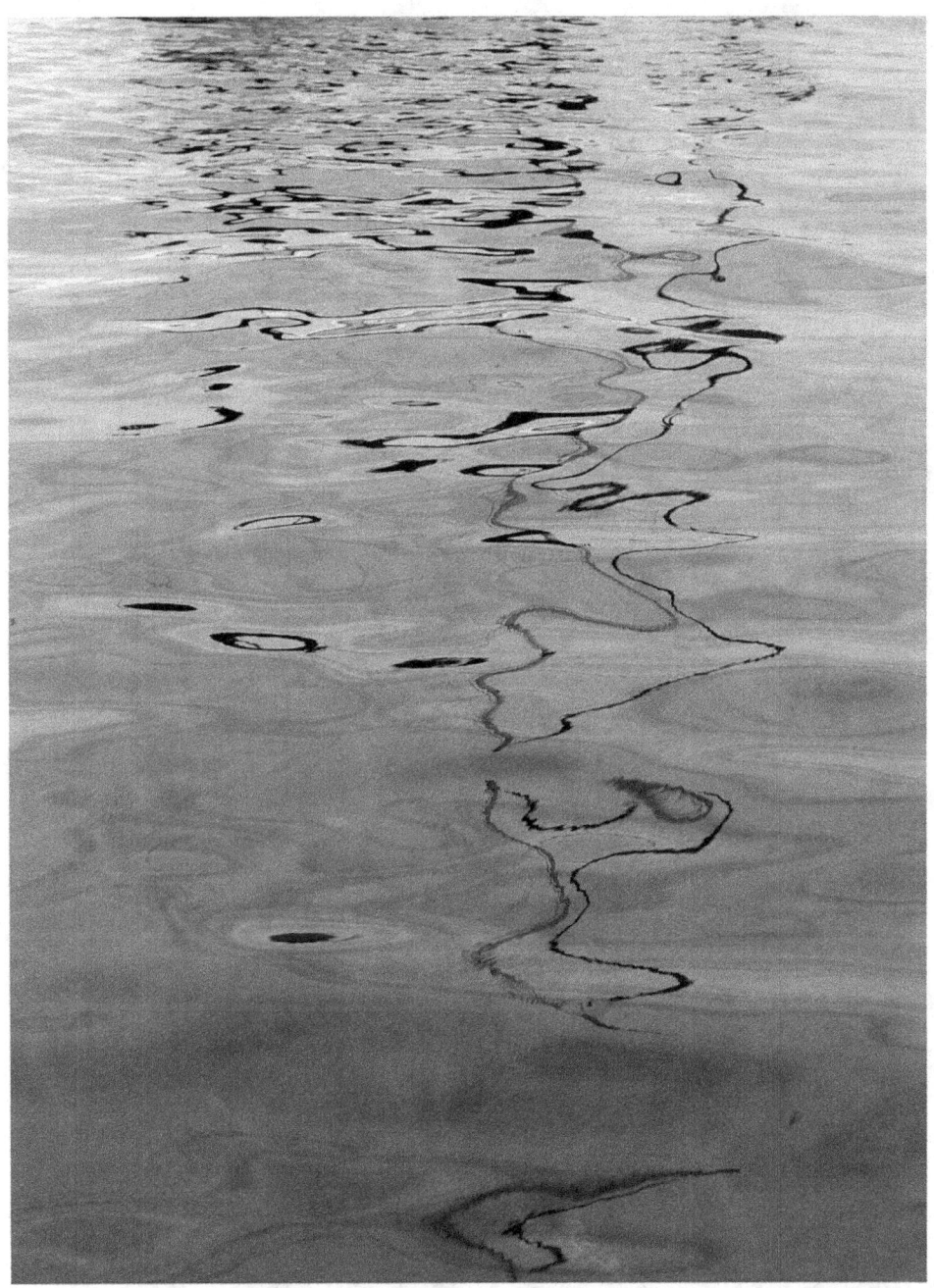

Before I had opened the side door to my house, I could hear the razing sound of my wife's voice unmercifully shredding into someone. I sat down on the floor of my garage and stared at the cigarette butts strewn about like extracted cartilage…Her voice continued. I closed my eyes.

Even the tides are given an occasional rest by the moon, aren't they?

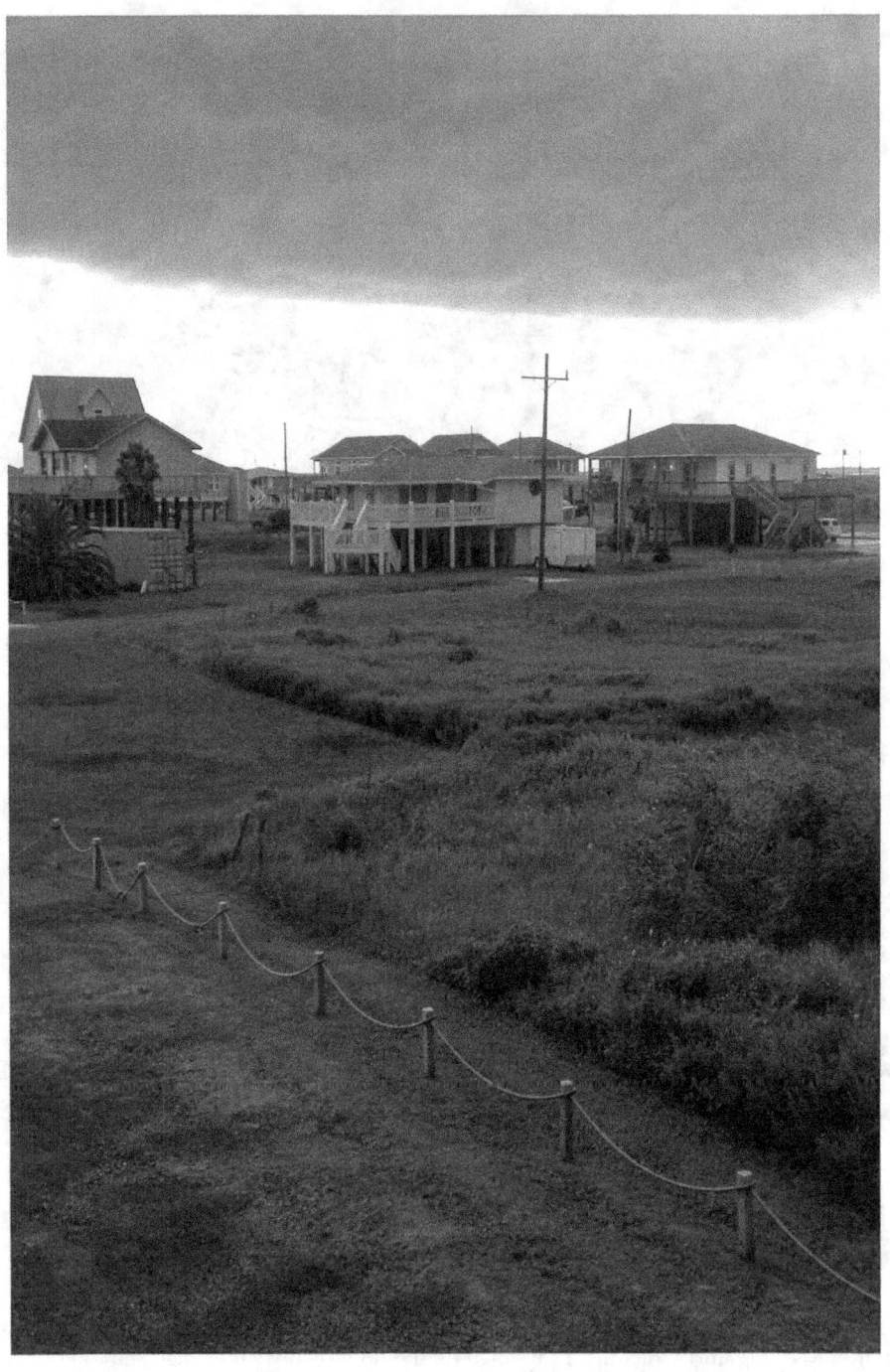

"I don't care who's listening. This neighborhood is filled with a bunch of fuckers. A bunch of lousy fuckers," she said raising her voice even louder.

I didn't want to respond. I wanted to shove it in that gaping space with all the other pointless endeavors that went nowhere but toppled through inner space and would continue to fall until the day I ceased to exist.

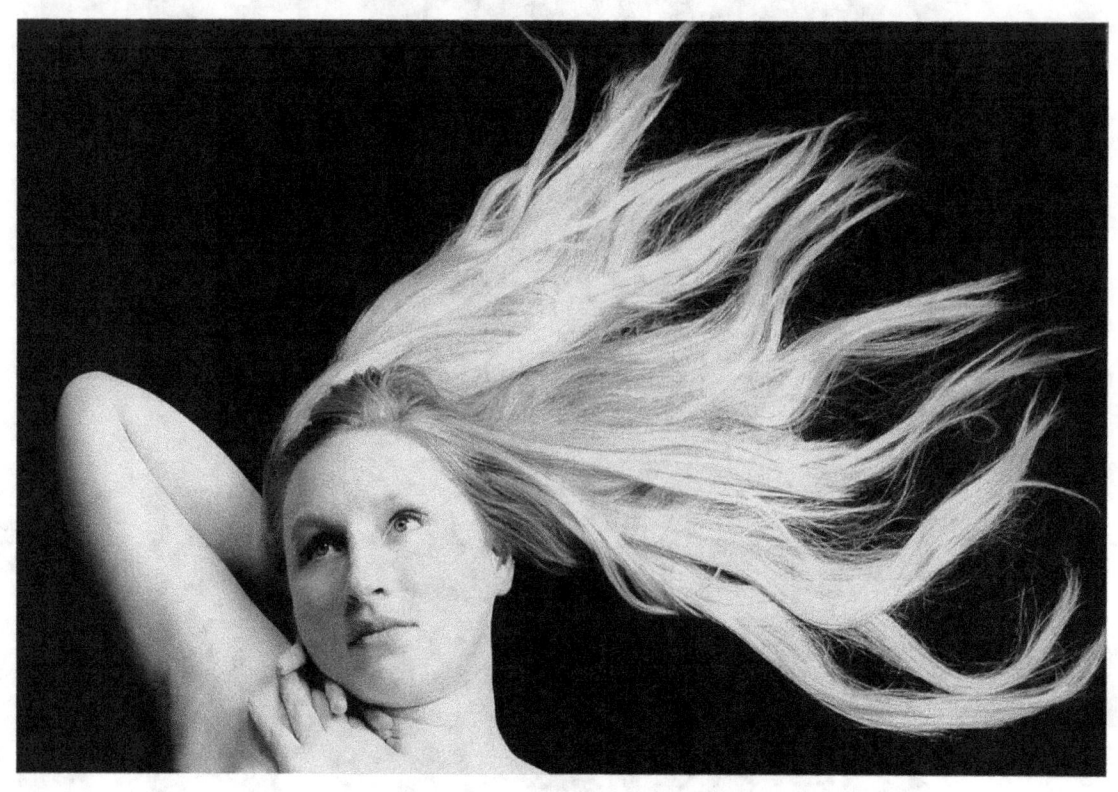

There were hours before she could go to bed with
a clean conscience.

That's all she does. Sits in that fucking garage and drinks and calls people while I sit inside waiting for every new catastrophe.

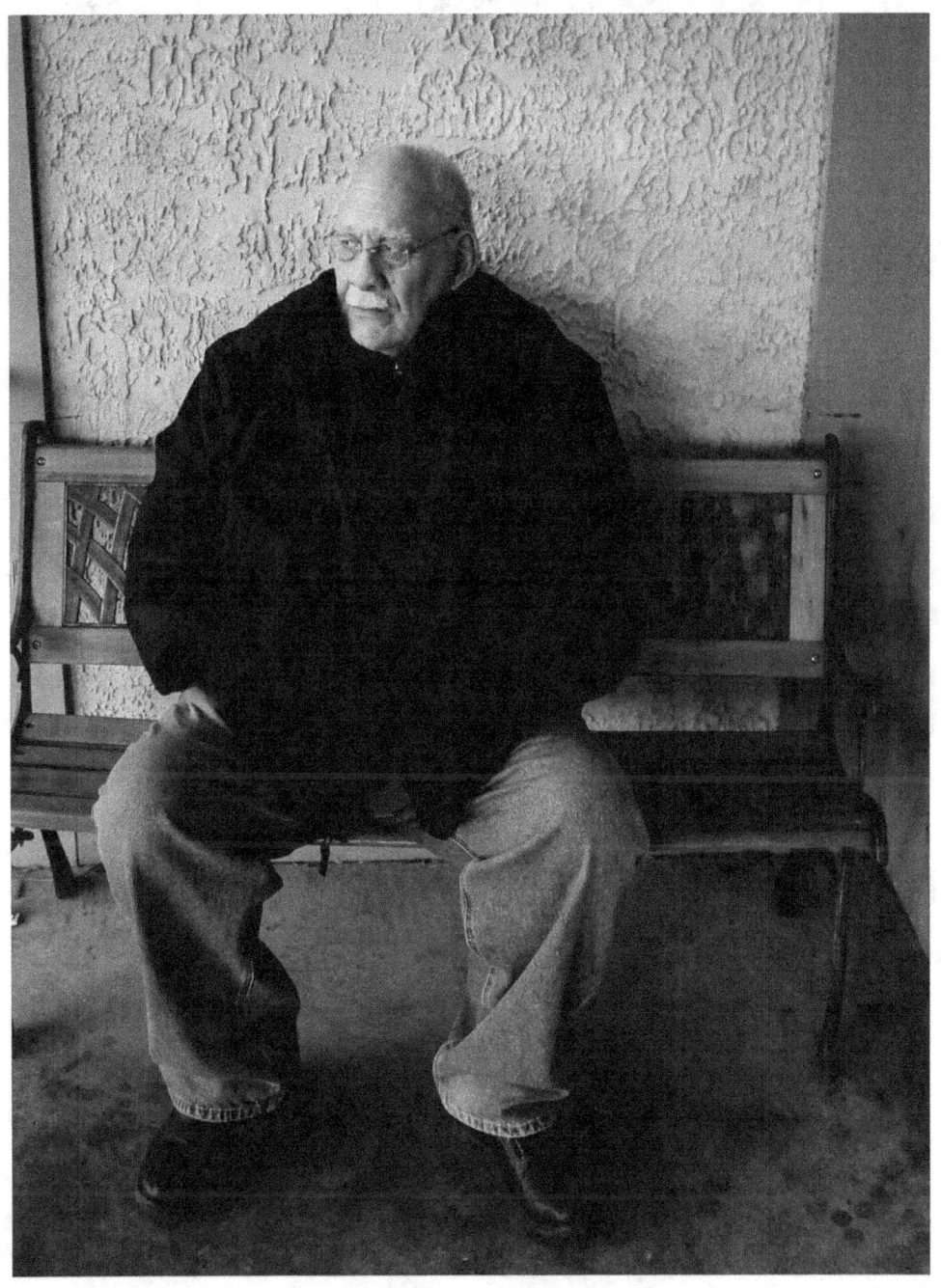

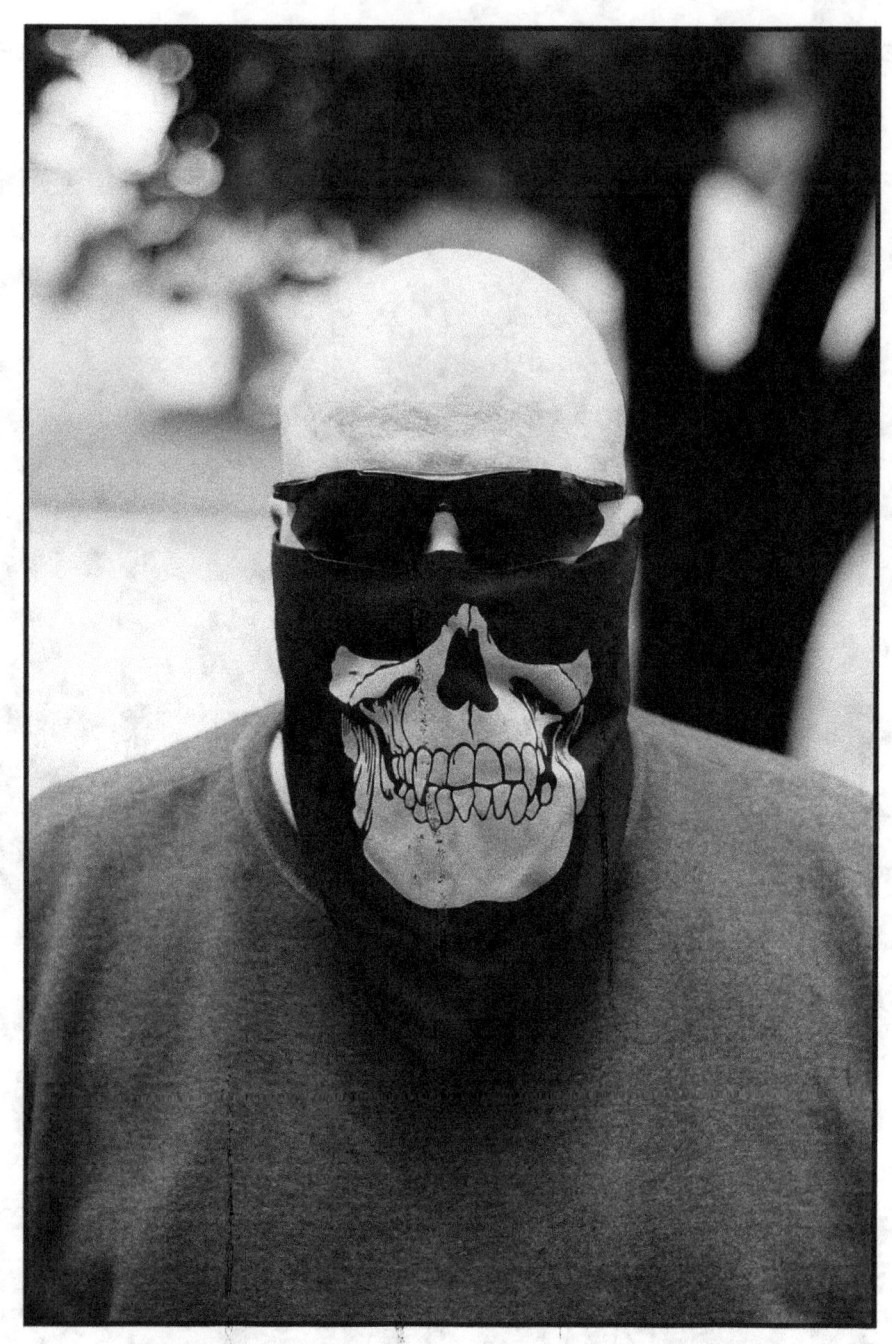

"Well, aren't you going to say anything?"

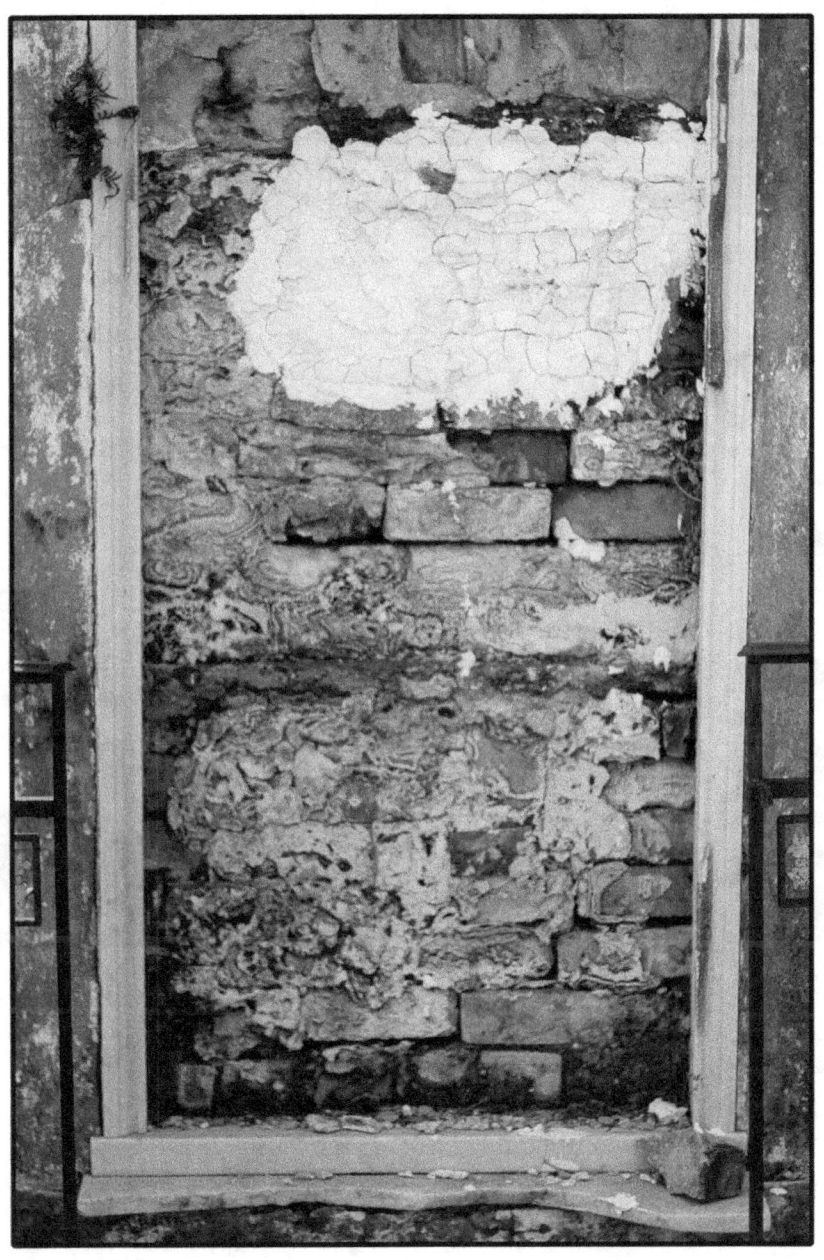

The slamming of the door shook the walls and made the pictures tremble, the tangible manifestation of this woman that would not die.

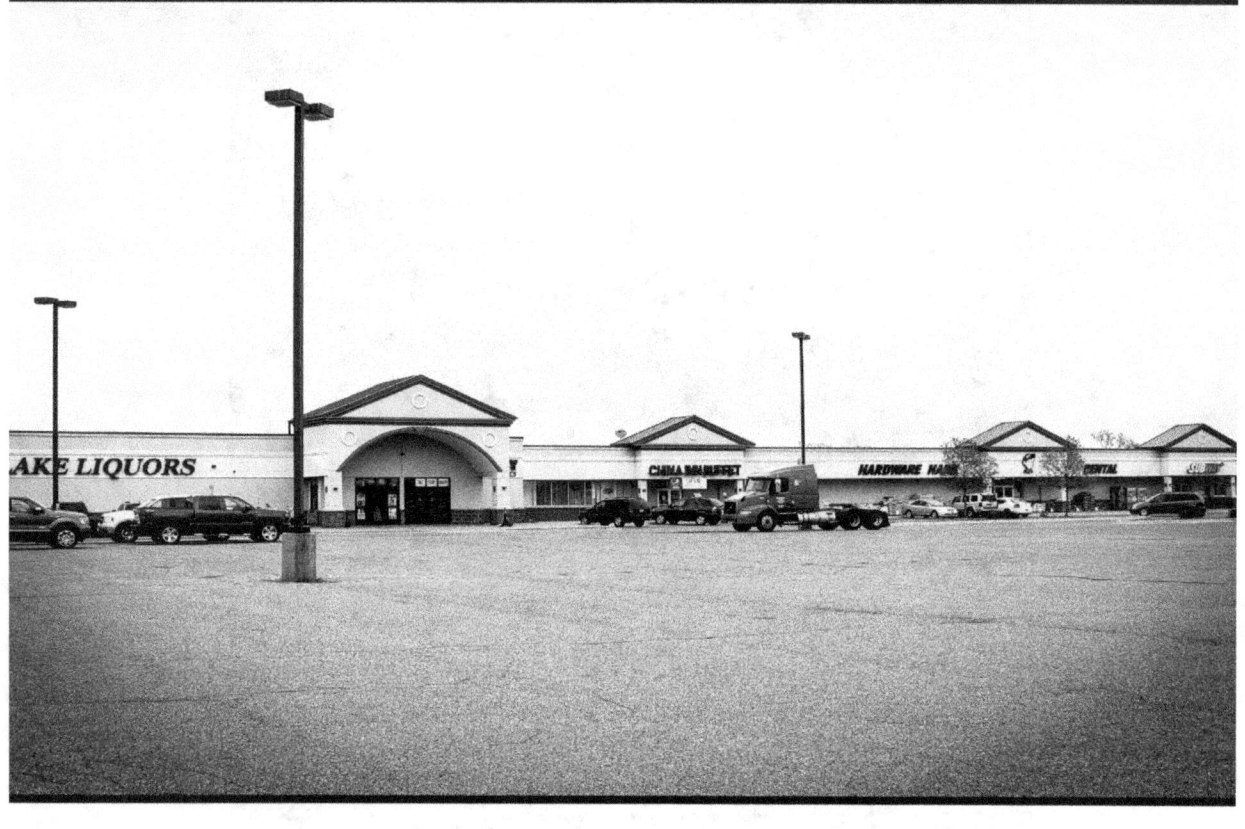

The city was too big.
There were as many liquor stores as churches and strip malls.
By the time we got to a liquor store she might have been at she would be on her way somewhere else. But what other option did we have?

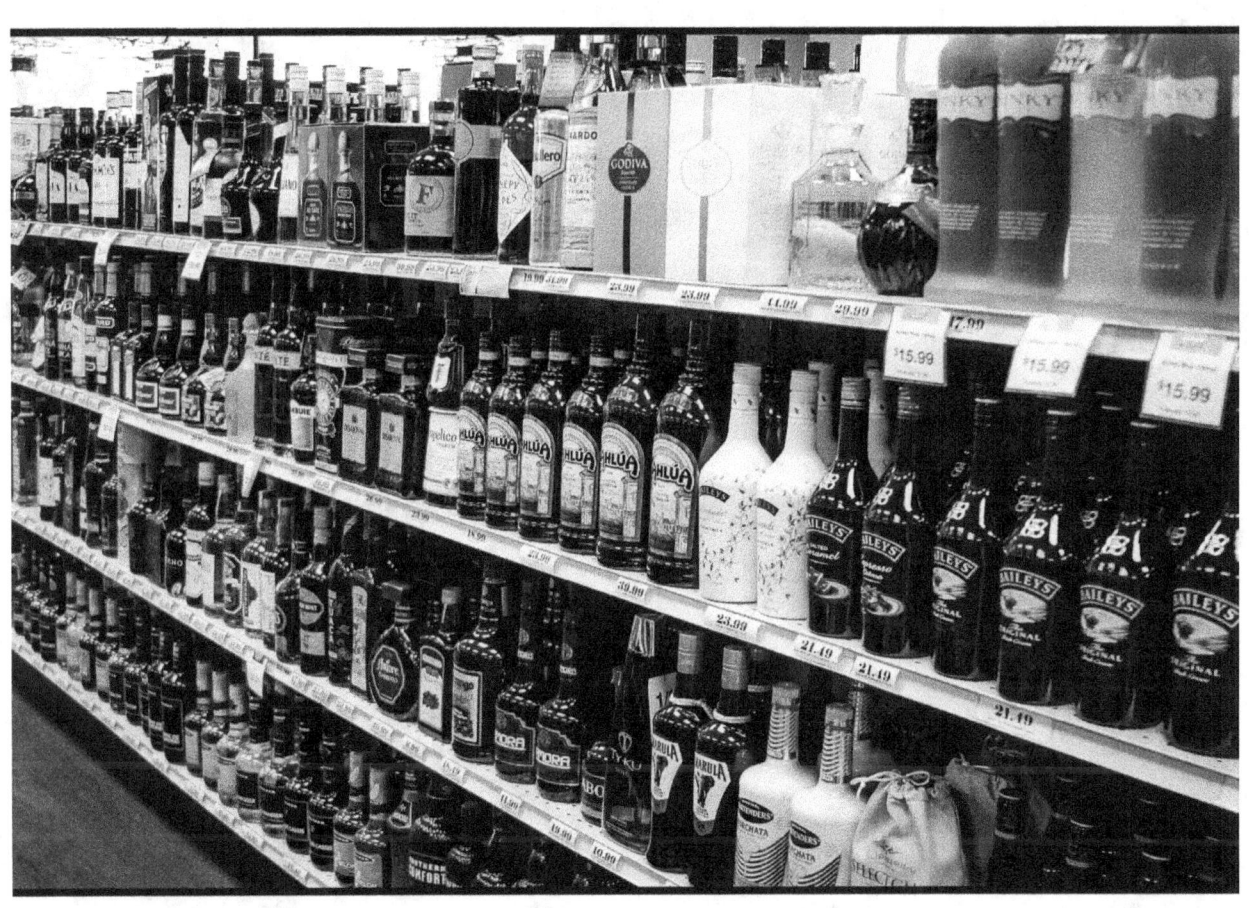

We entered the liquor store.
Shelves lined with bottles filled with every colored liquid,
dressed in every conceivable design
like uniforms of destruction stood at happy attention at our return.

Although it was rush hour here no one was anxious to get anywhere.
Stasis was the point.

THE HIGHWAY WAS GRAY AND UNBENDING.
THE URGE TO SLEEP OR PULL OUT A GUN, SHOOT MYSELF
AND CAREEN INTO ONE OF THE COLOSSAL CEMENT SUPPORTS
OF THE OVERPASS TEARING INTO THE NIGHT
WITH A METALLIC THUD WAS OVERWHELMING.

INSTEAD I SKIDDED INTO A GAS STATION TO GET AN APPLE AND A PACK OF GUM.

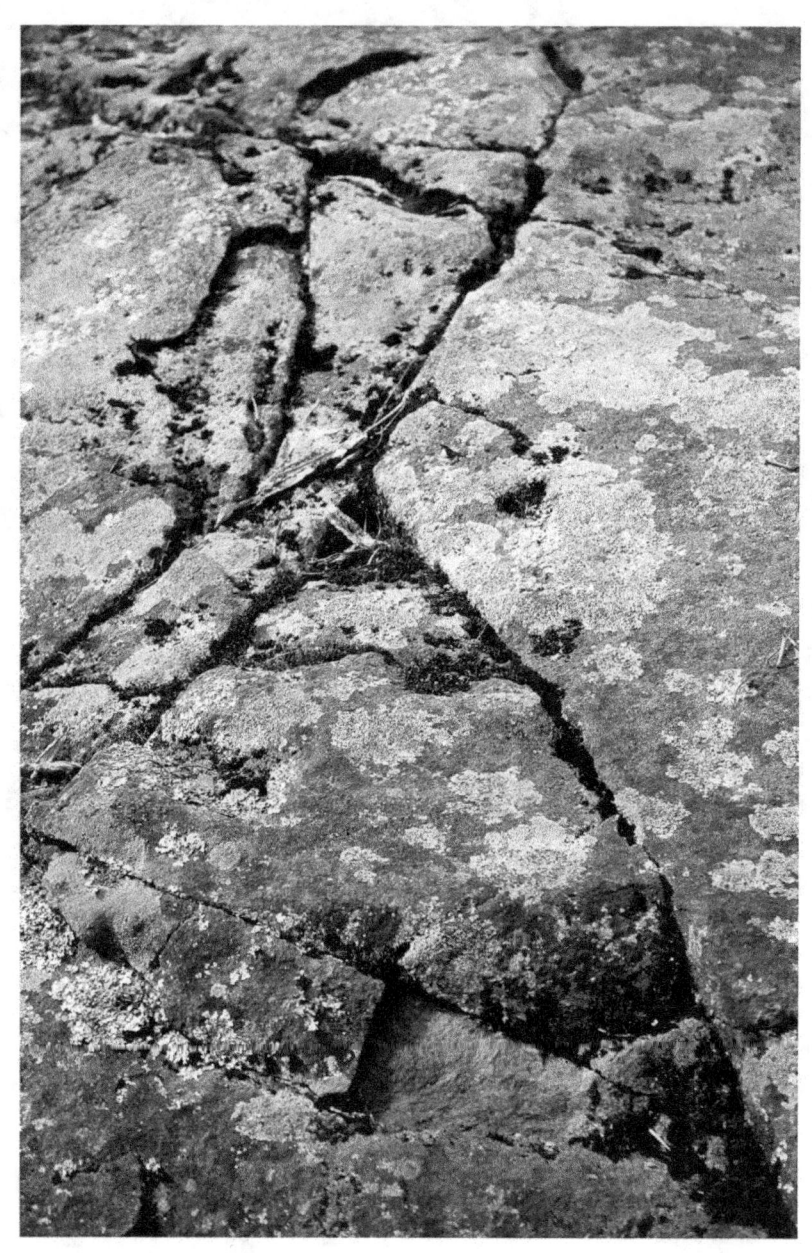

THE FAULT LINE INSIDE ME QUAKED.

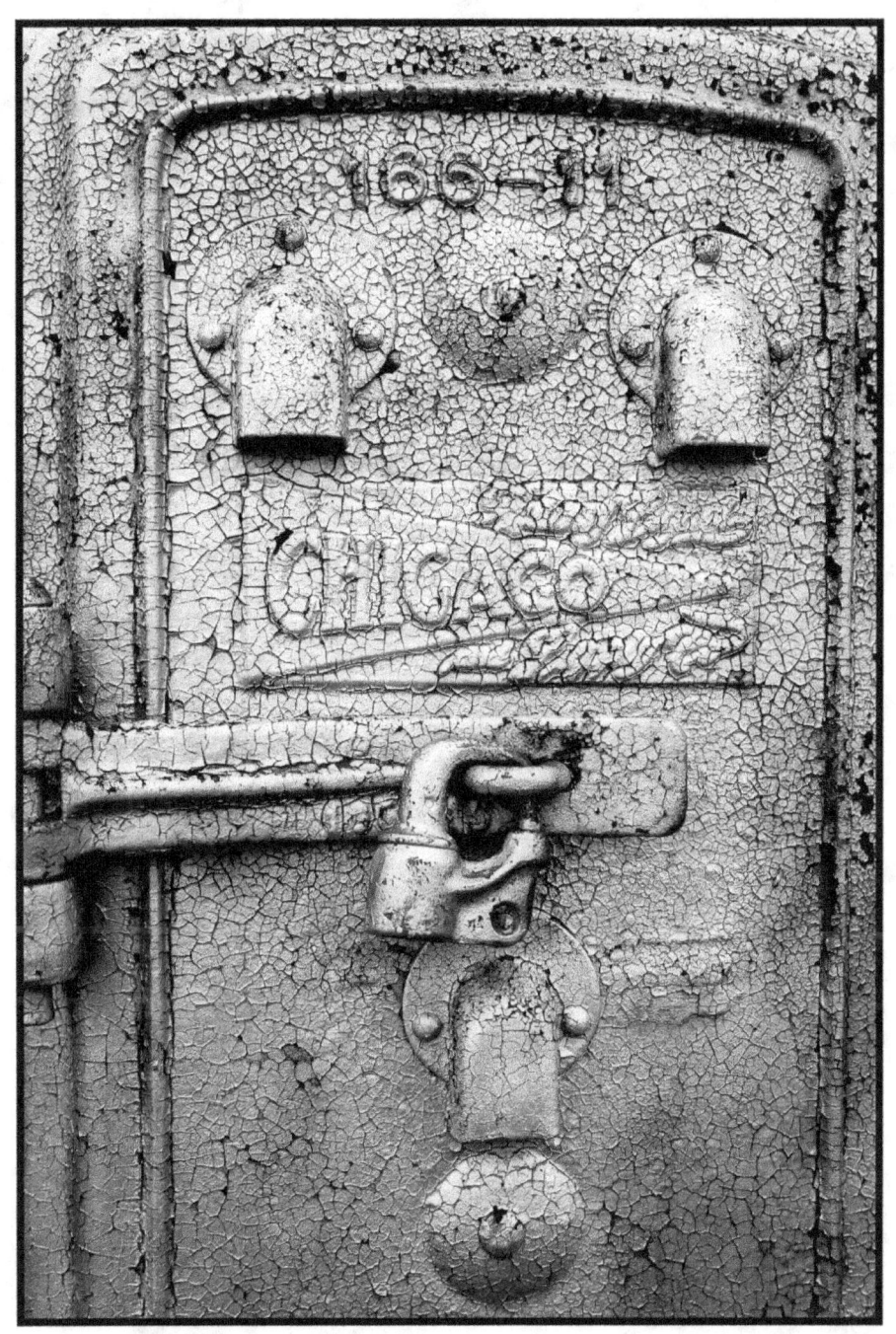
I RECKONED WITH THE CLOSED DOOR
TURNING THE KNOB SLOWLY I PUSHED ON IT AND WAITED.
NOTHING.

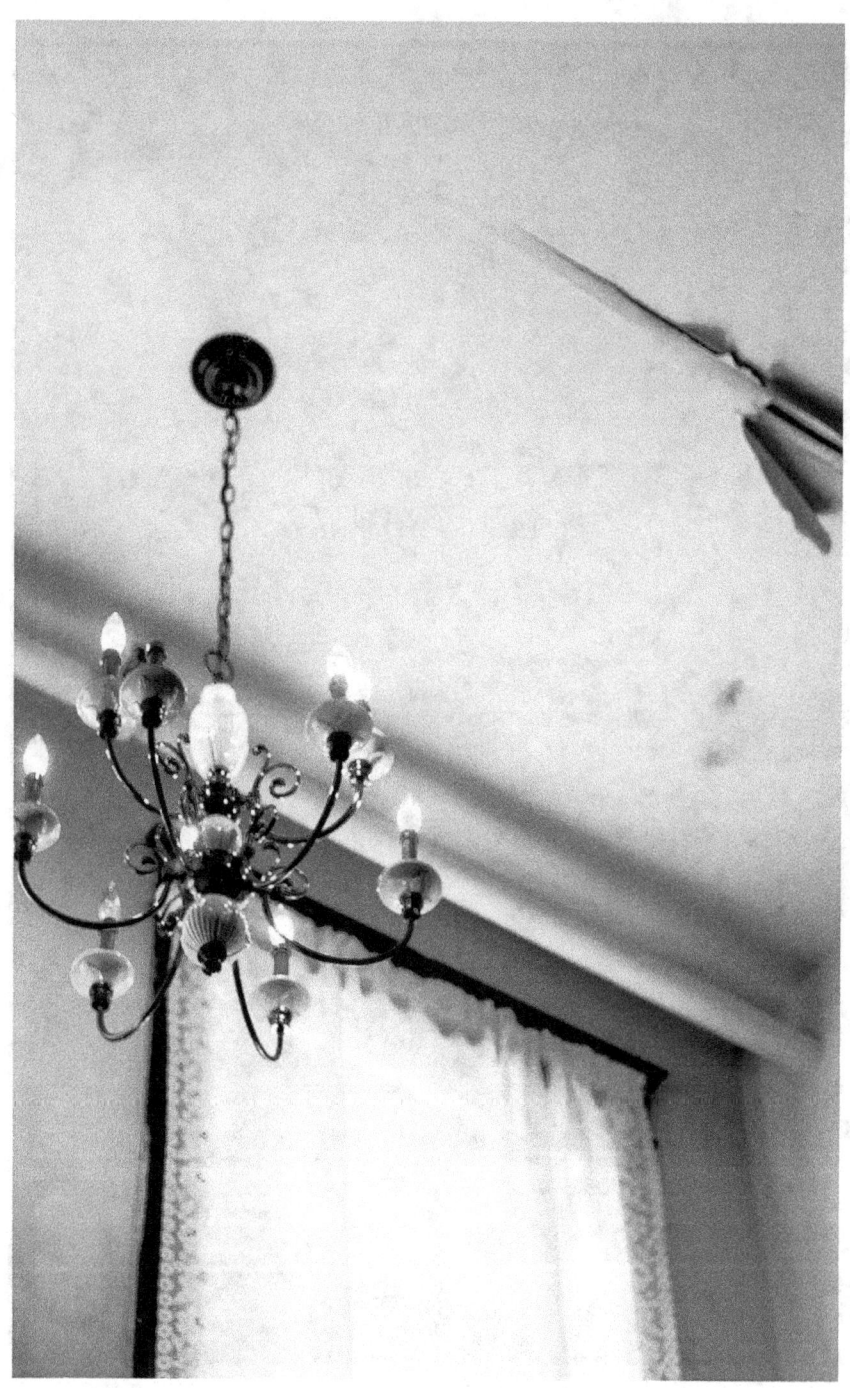

"Remember when we first moved in how we would go room to room, with champagne,
and giggle like we couldn't believe we got this place?
Like we had pulled something over on the world?"

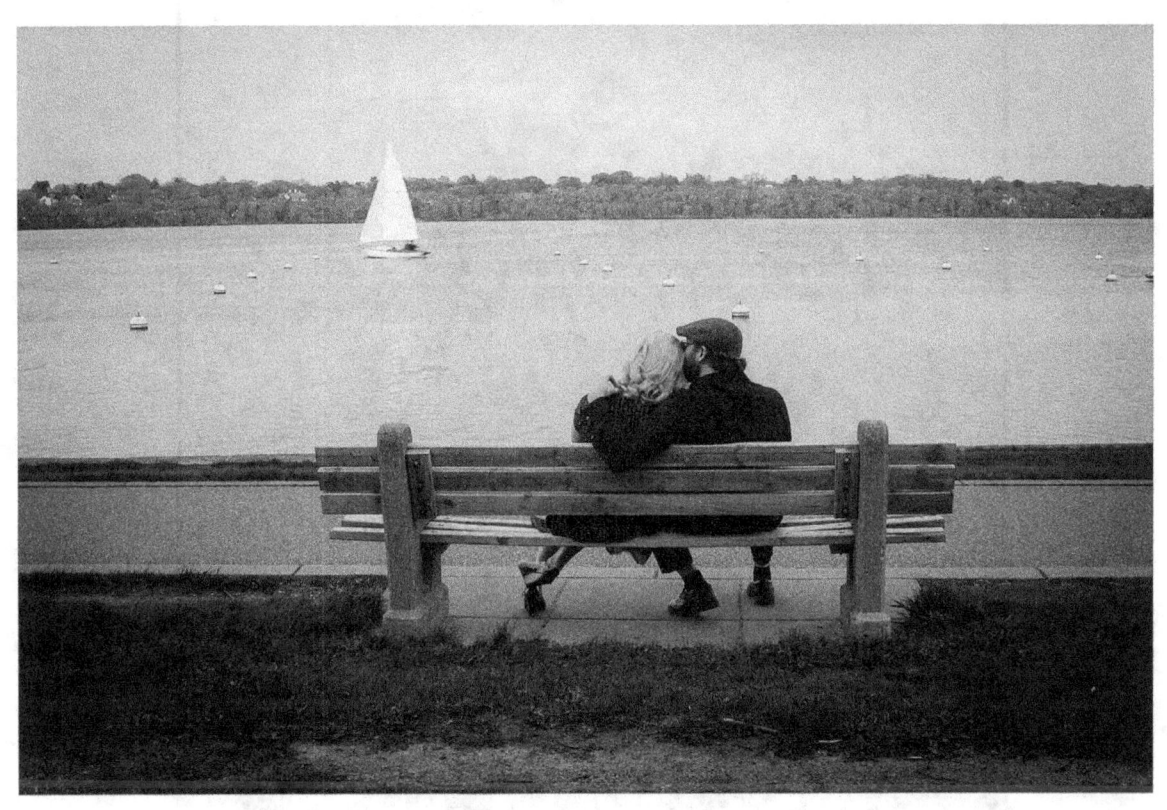

We did it soundlessly, without speaking,
with that intangible rhythm of people
who have known each other a long time,
in intimate ways,
in ways they themselves do not even understand.

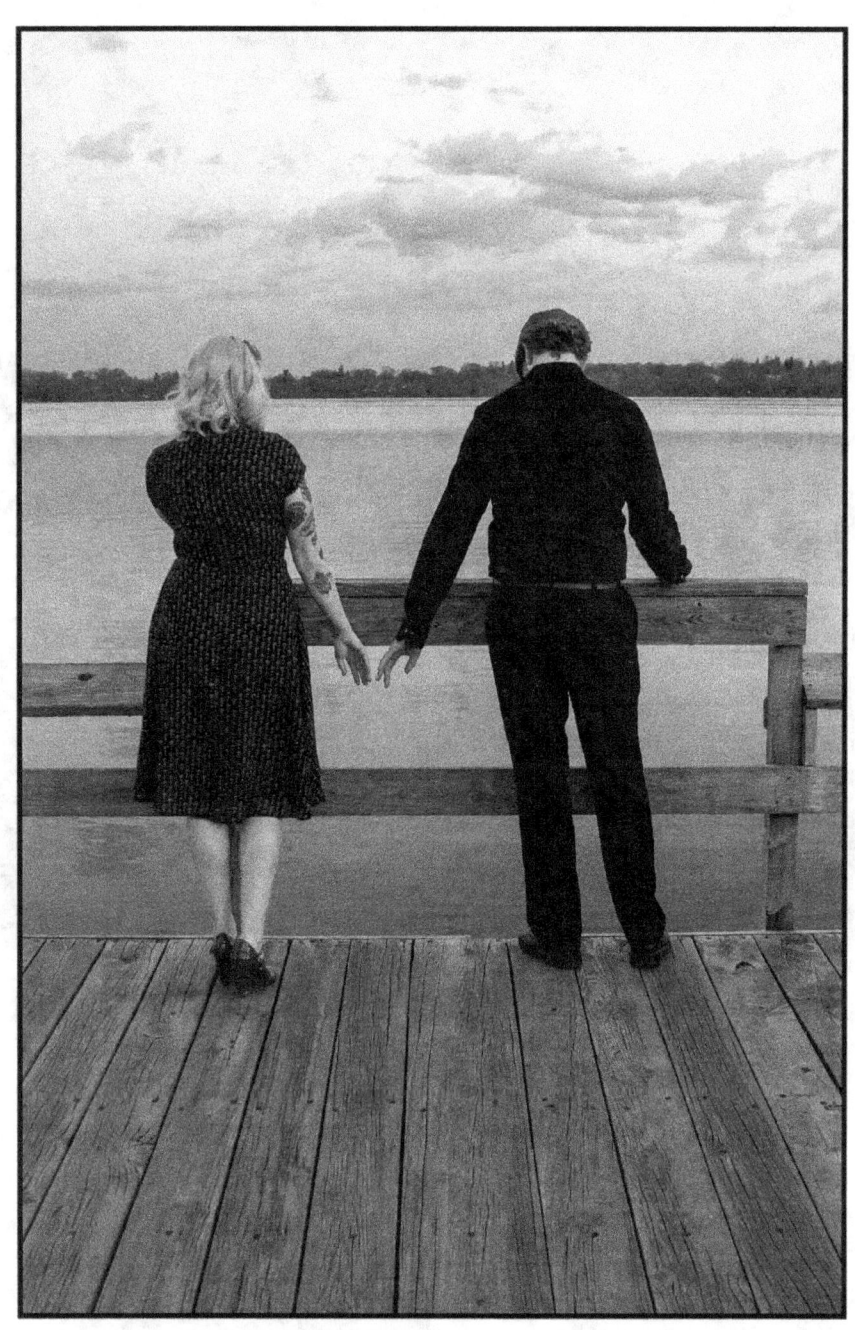

They sat in strange limbo of intimates broken in two, whose bodies and brains longed to slip into the old, comfortable, transcendent patterns: of speech, topics of conversation, movement of bodies like a train that's slid off a track and keeps trying to pull itself back up onto the worn, smooth rail but knows it must resist.

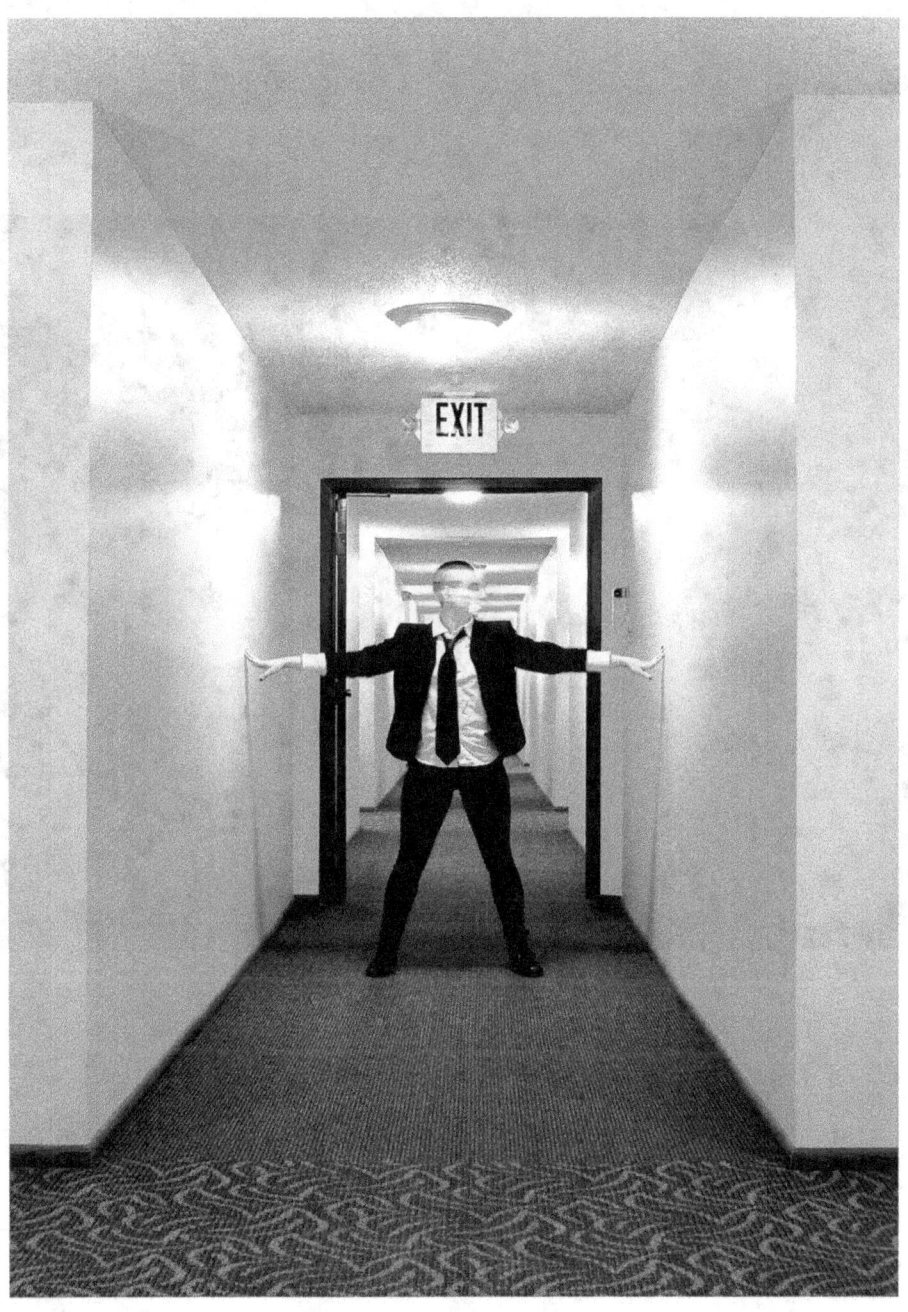

I didn't know what she was thinking or what the purpose of the entire evening had been,
a chance to reconnect or some long con I was unable to forecast.
For all our years together there were still times when this person was an absolute stranger to me,
an opaque mystery. I suppose I was to her as well, though I doubted it.

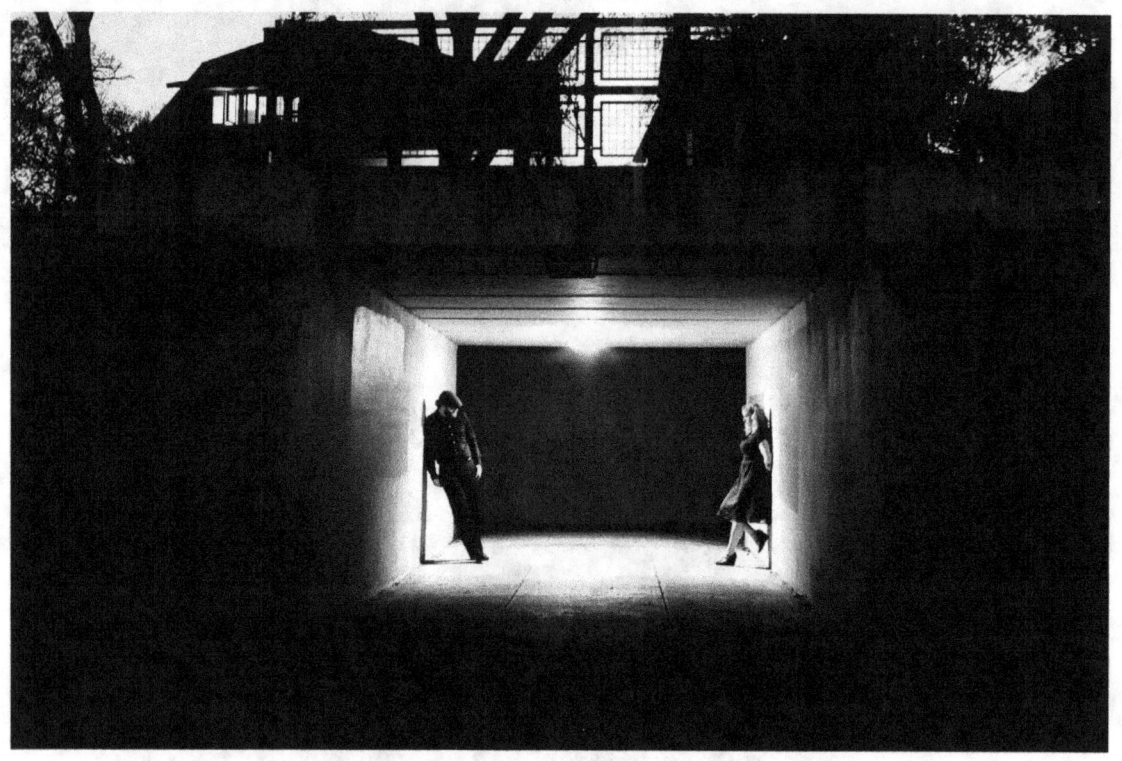

At the end of the night we sat staring at one another, restless, unsatisfied, bloated and sober, unsure if the experiment was successful and should be tried again.

sunshine like shattered diamonds fell upon me.

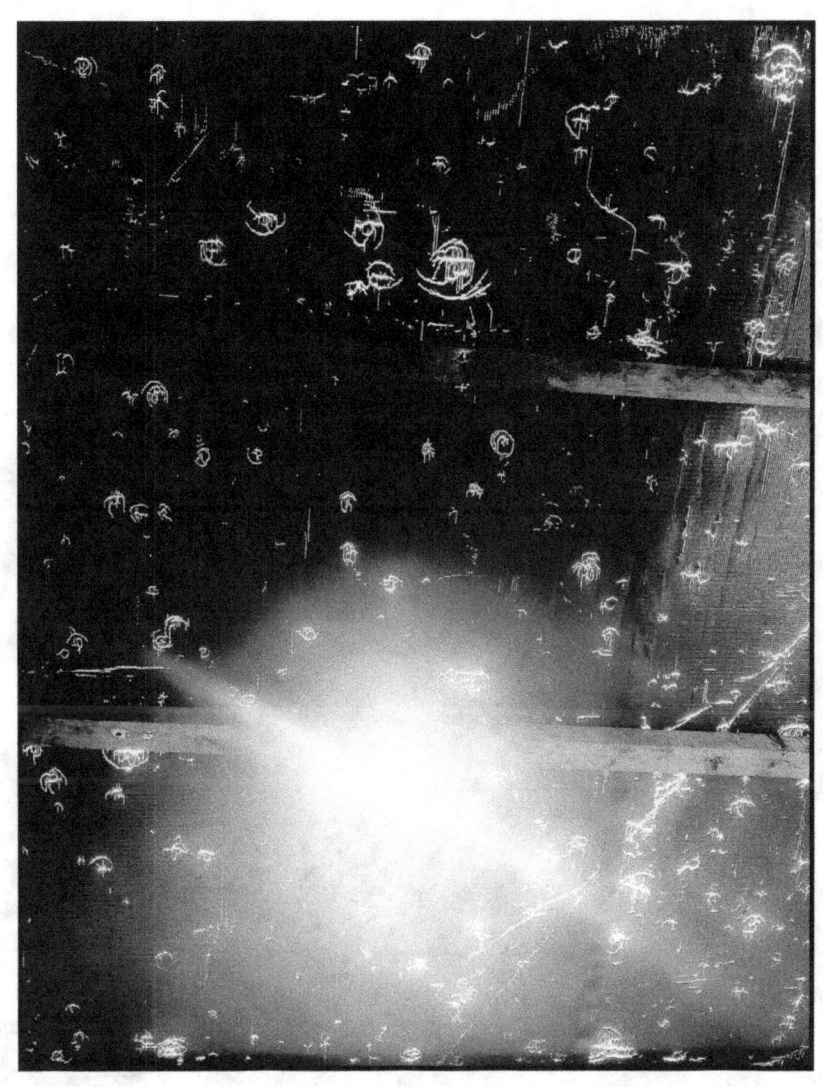

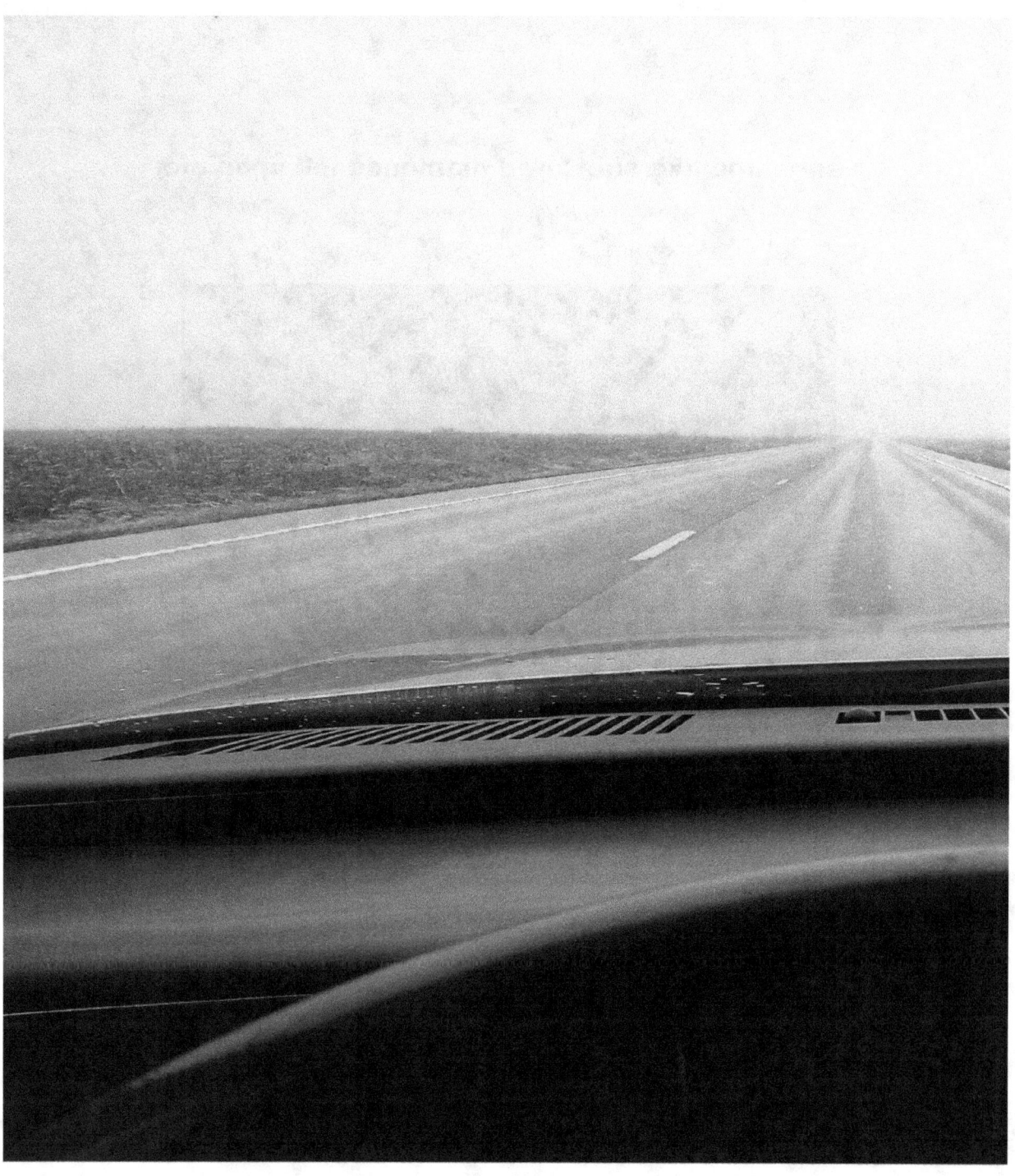

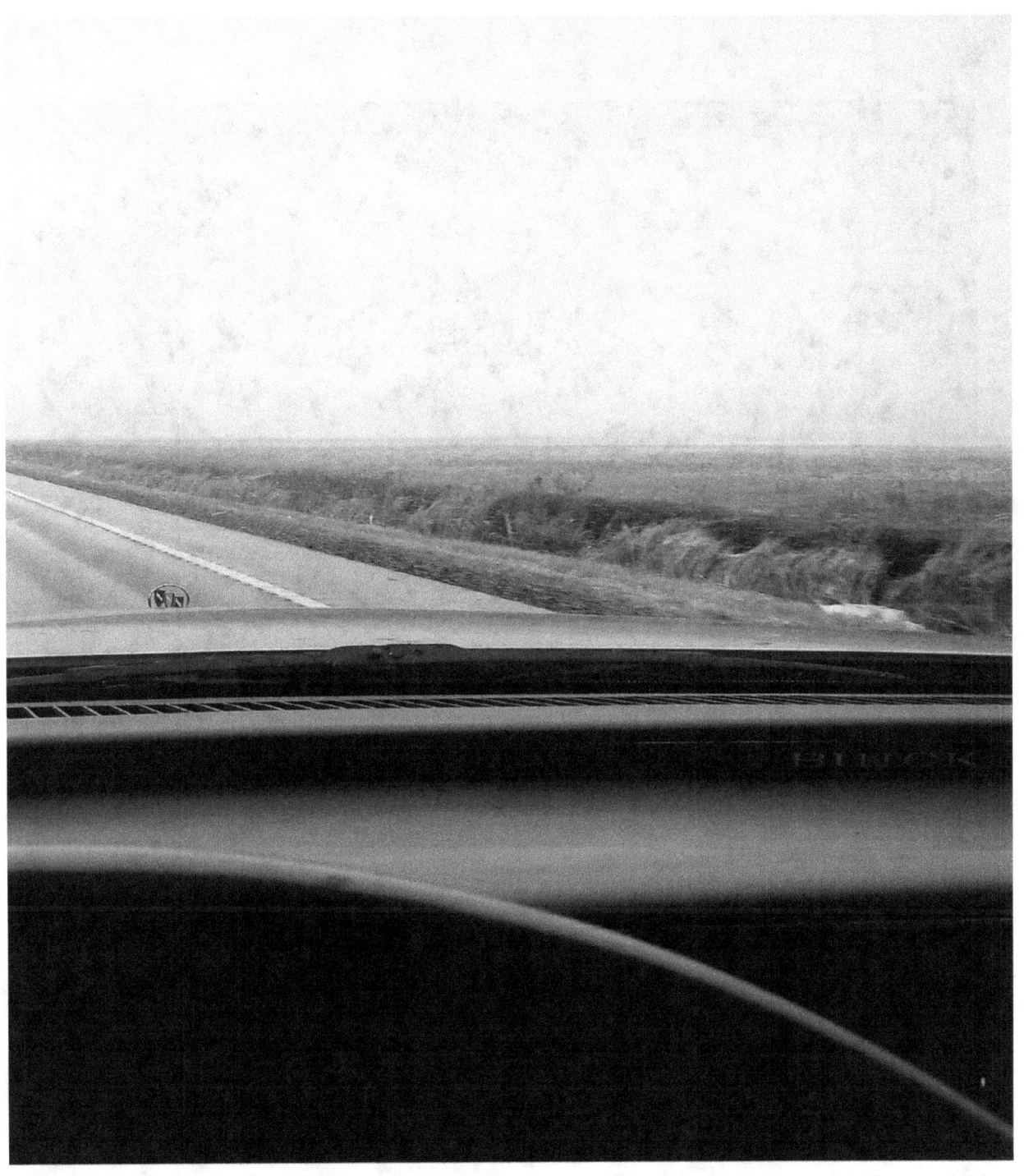

The two lane highway cut like a scythe through reaching stalks of corn and claustrophobic dormant fields. Despite the autumn chill I kept the window down and the radio off.

There were no other cars. No lone bikers or joggers edging the shoulder.
No sudden deer making a desperate break for it.

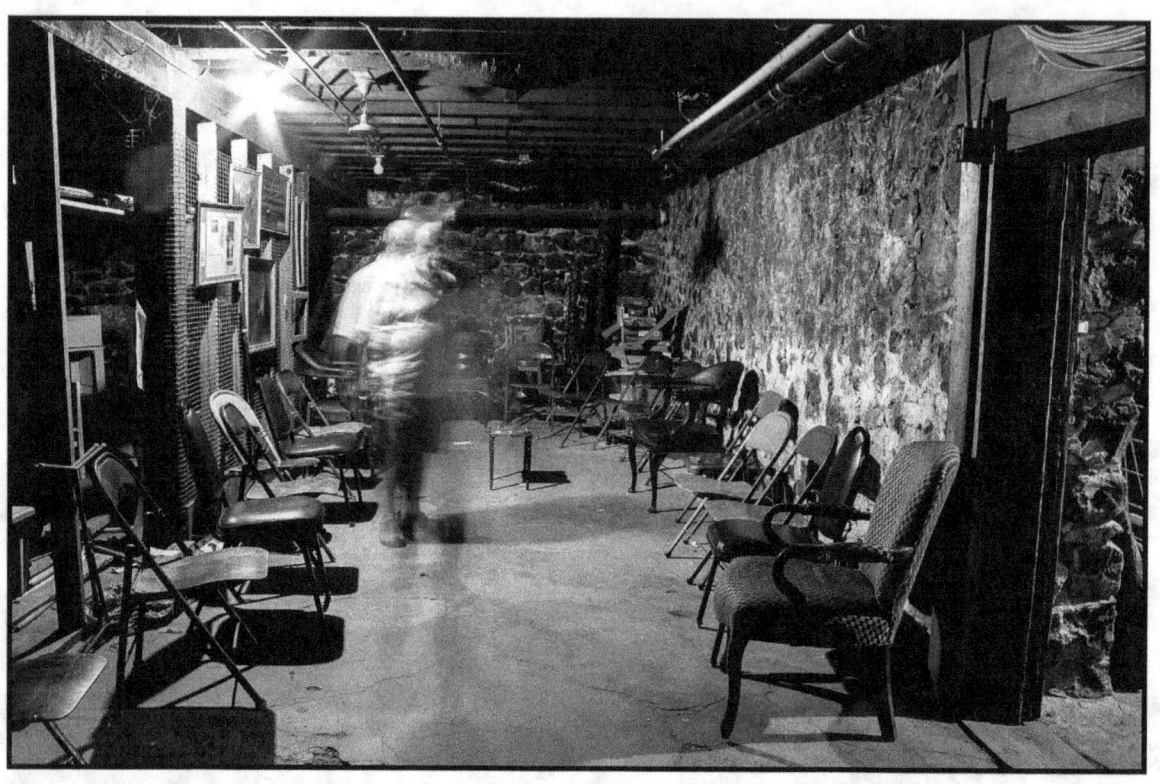

"The memories have short-circuited.
They still rise but like ghosts have no substance, no emotive power.

This isn't heartbreak my daughter.
This isn't a song. Or a movie.

It's the slow dreadful dismantling of a mountain.
Each piece being placed on my chest
a hyena daring me to scream."

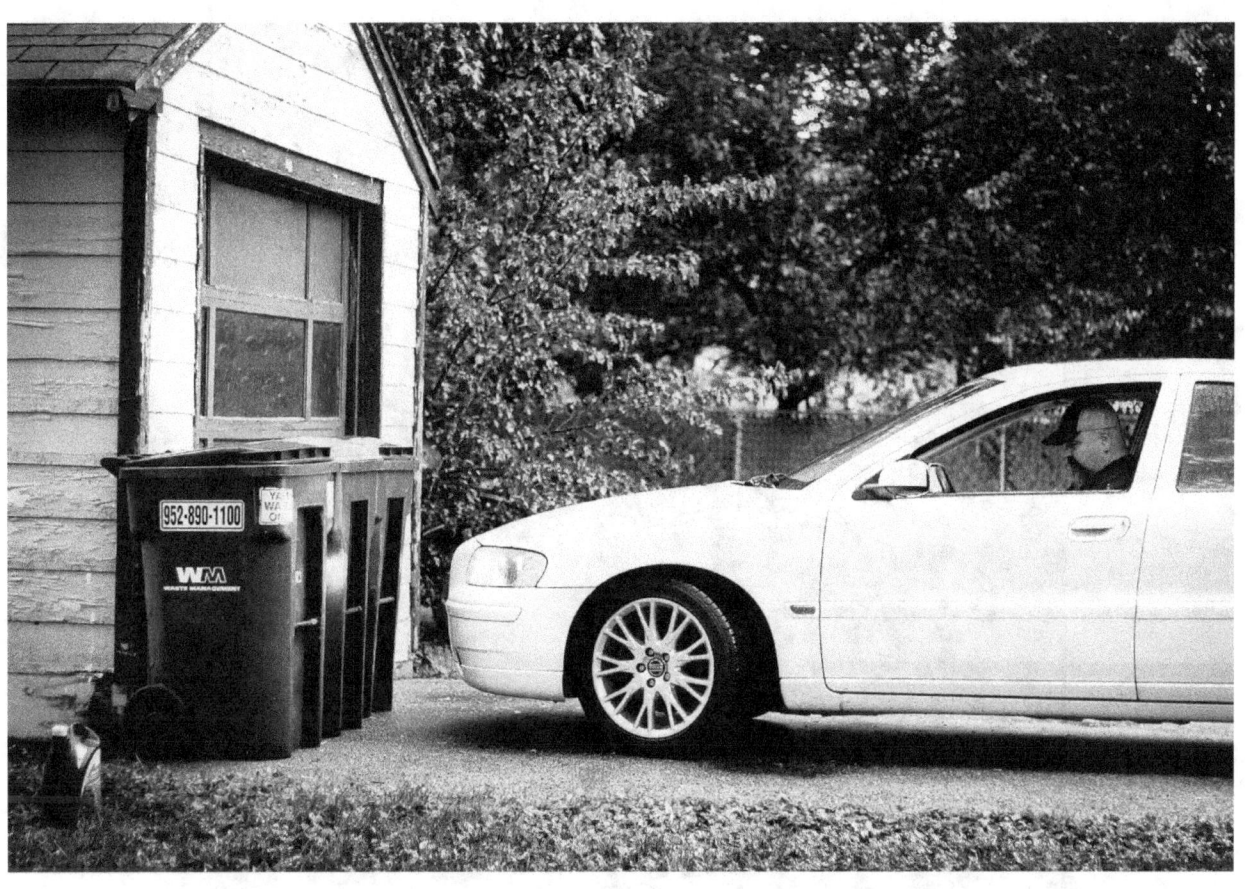

I drove fast, reckless towards my home.
Because in the end where else does a man run to?

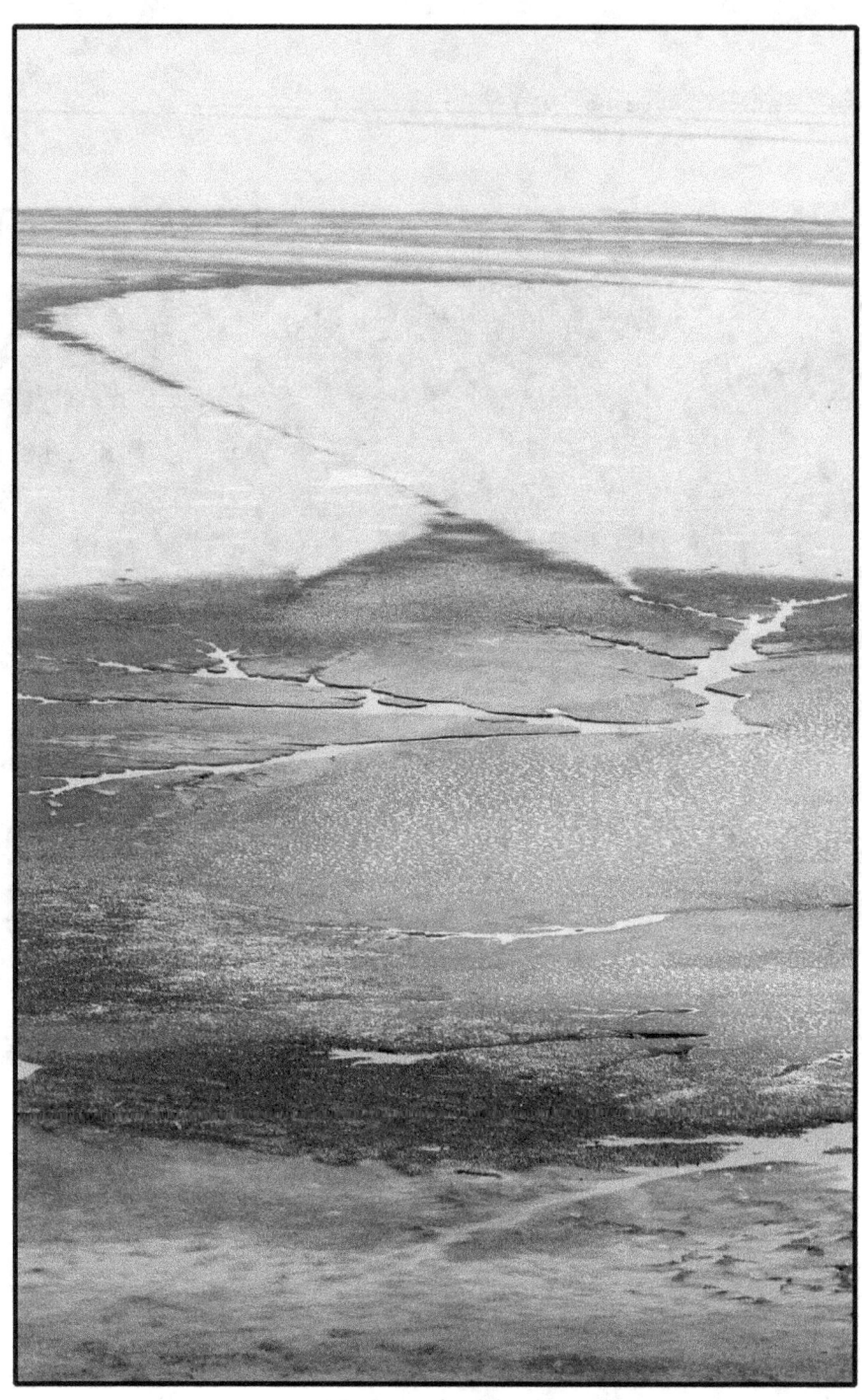

I realize this has nothing to do with the story above but like a car crash on the side of the road it's at least something to distract you on your way home.

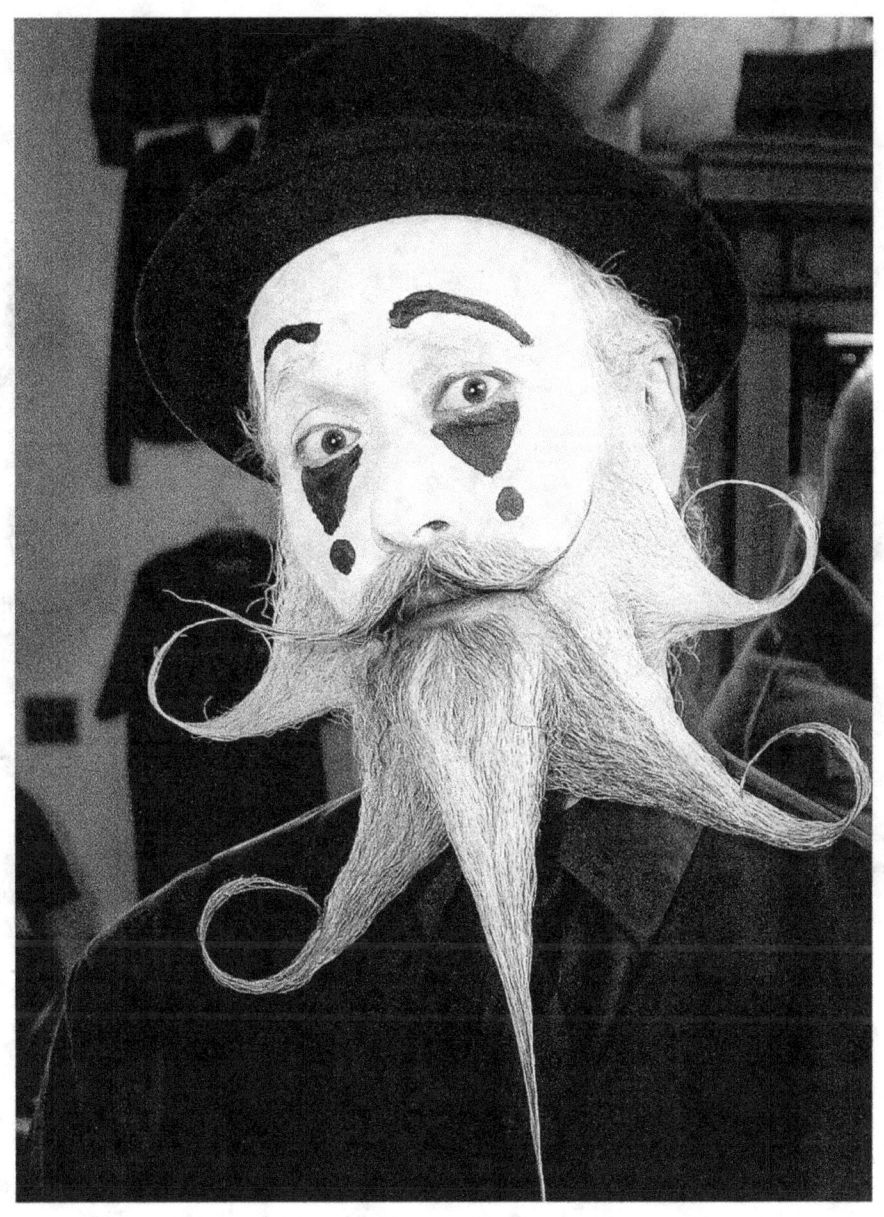

The cloying, needy tone of the comedian's voice
could almost be twisted into affection if you were high,
or act as a buttress to that anxiety
that struck like lightning the moment you were alone
if you didn't think too hard about it.

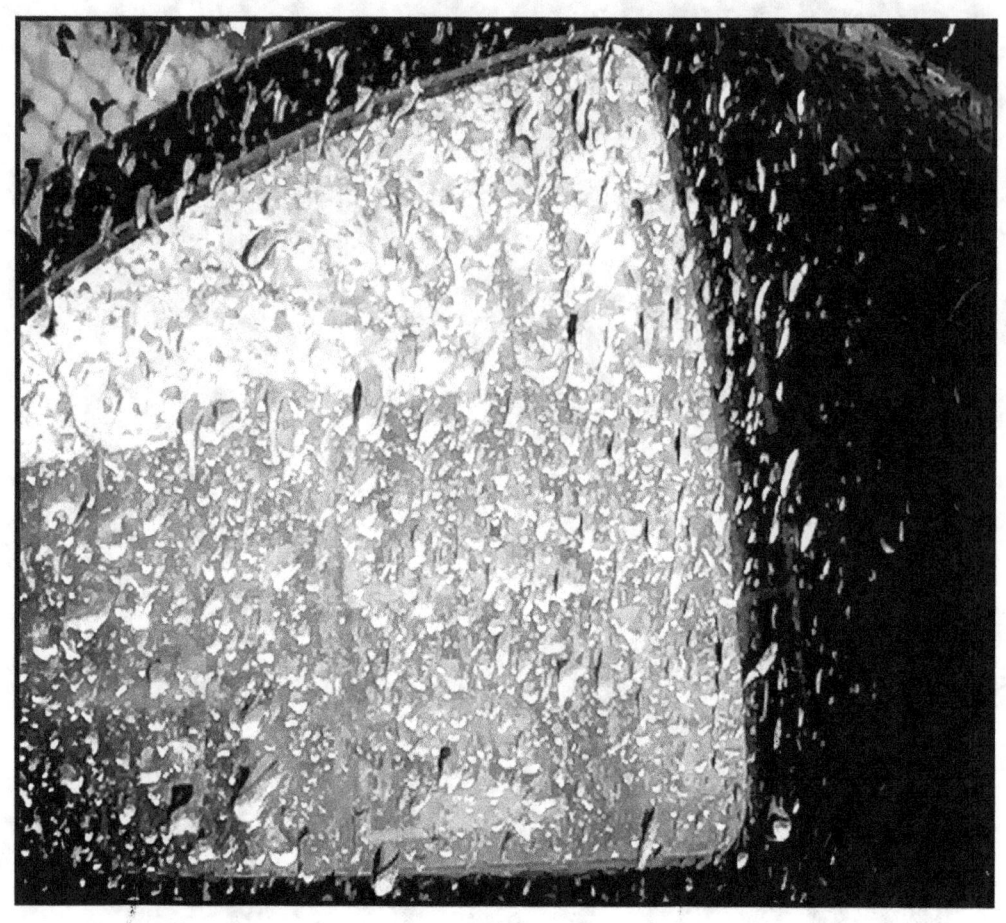

*His gaze well past me, out the large windows, at the watery gray sky
Slowly a forceful resolve came over his face.*

*It started in his eyes and spread down over his cheeks and nose
and finally to his mouth.*

*"Okay," he said nodding, "That's a great idea," he added,
the strength of the idea and his resolve gaining a new momentum.*

"But I'm going to go right now,"

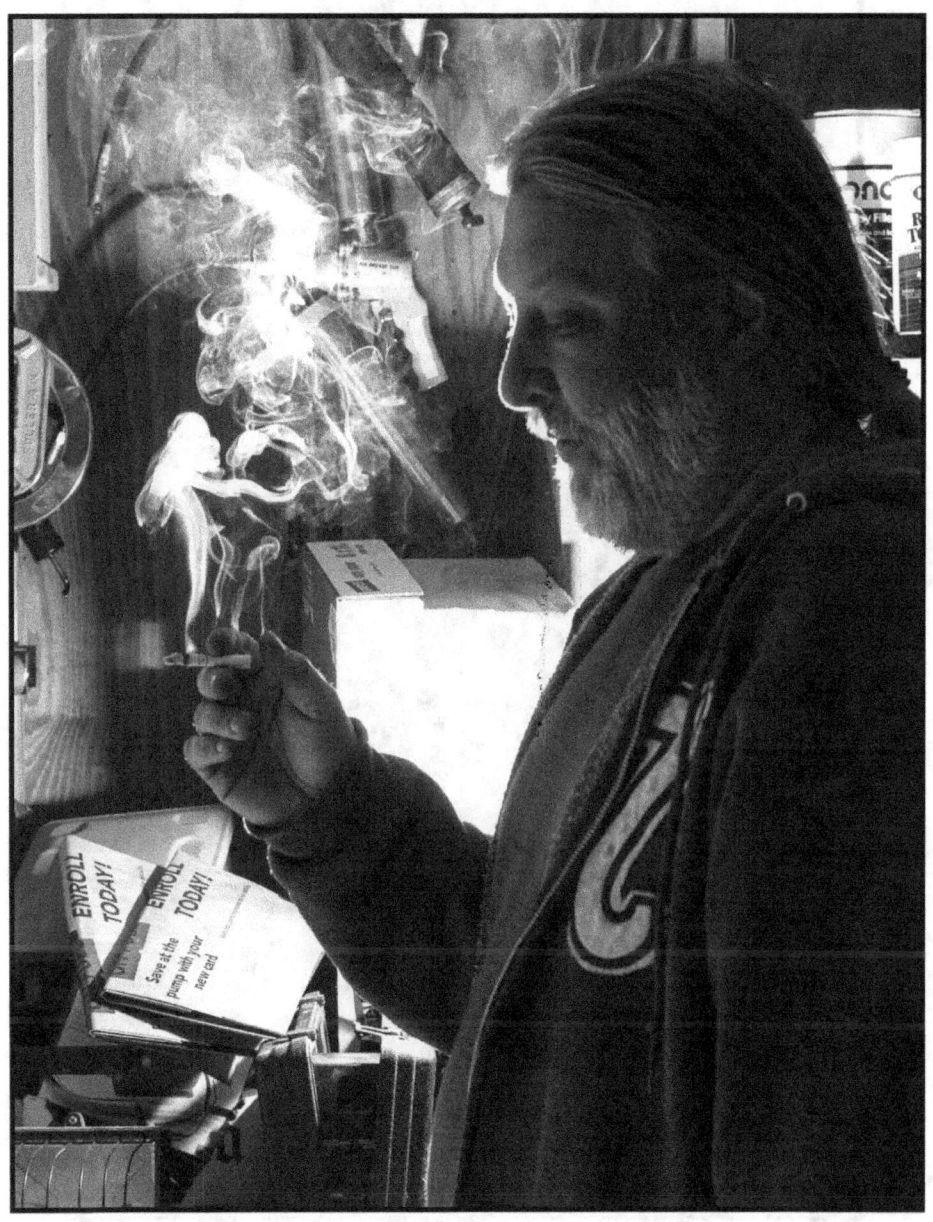

"I think they should put a kill cigarette in every pack. Like Russian roulette. I mean if you've decided to kill yourself - might as well make it interesting.

You smoke it, dead.

Anyway, it would be more honest."

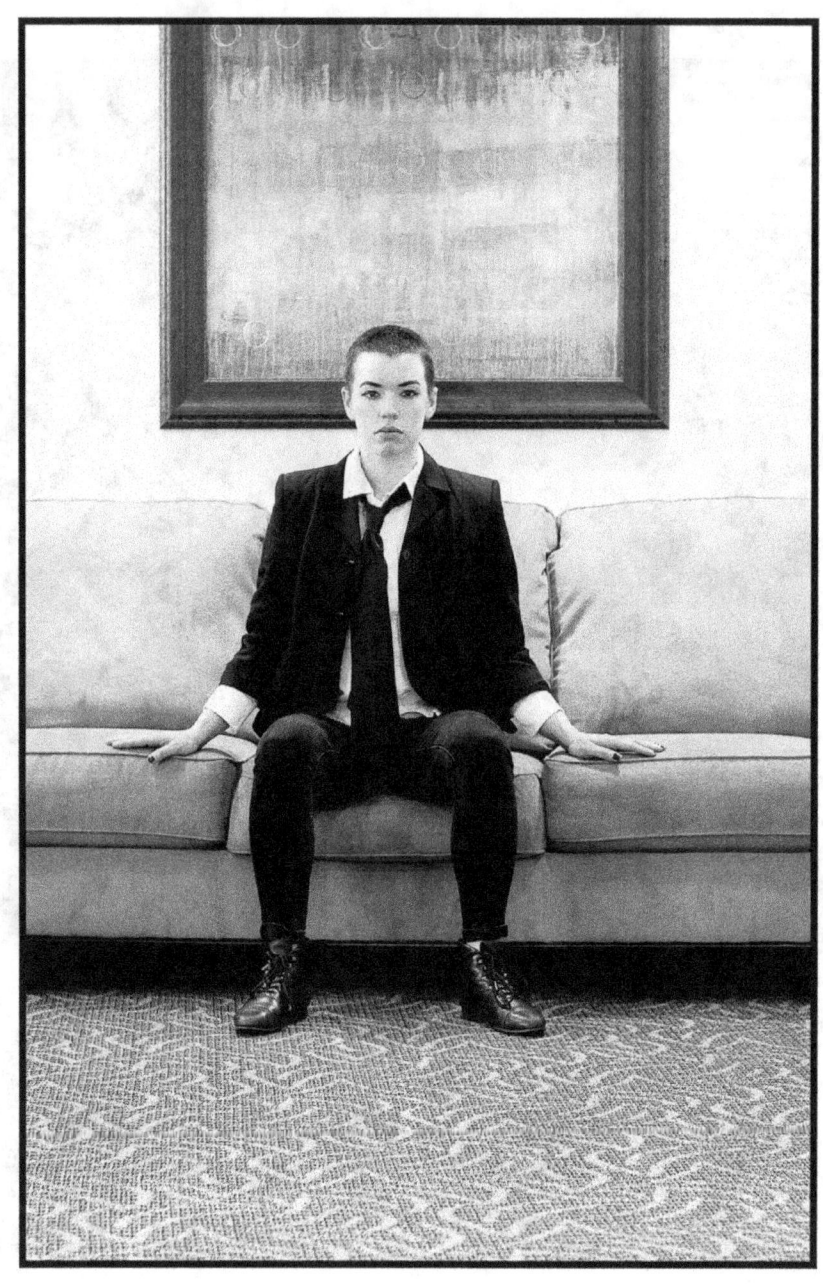

"I want to be Rimbaud. Not the seer of the enfant terrible like before," Daisy responded her voice without emotion.
"But the older Rimbaud, if one can truly speak of an older Rimbaud,
(it seemed as if she were speaking to someone or to some lost part of herself certainly not to us although our presence was integral)
the hard, stalwart, stubborn, sternly sober, nearly puritanical Rimbaud.
Stripped of all illusions.
Alone.
All his angelic beauty scrubbed away by the African winds"

I didn't understand what my sister was talking about either but each word seemed whole like polished stones in a beggar's hand.

Or like music dissonant but soothing.

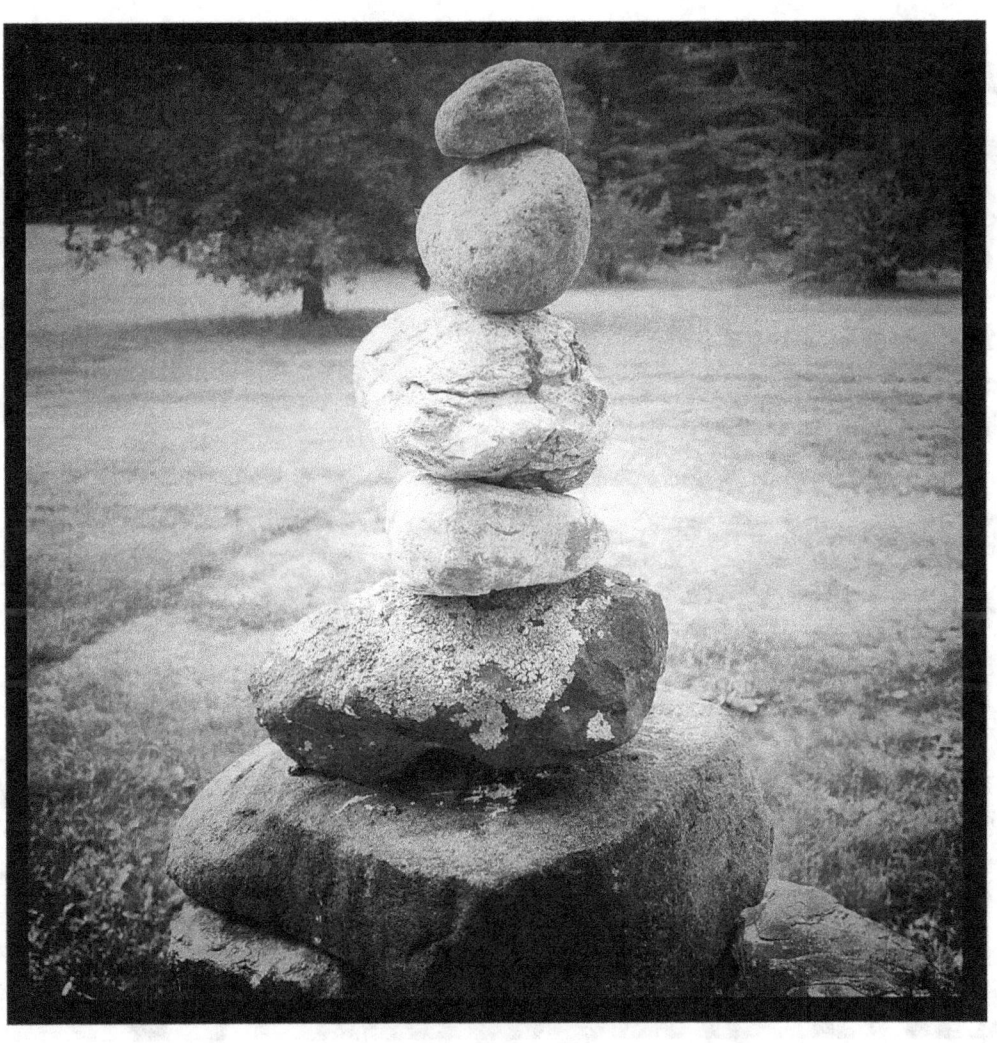

I do that, conjure up memories - the beautiful ones like ornaments on a Christmas tree.

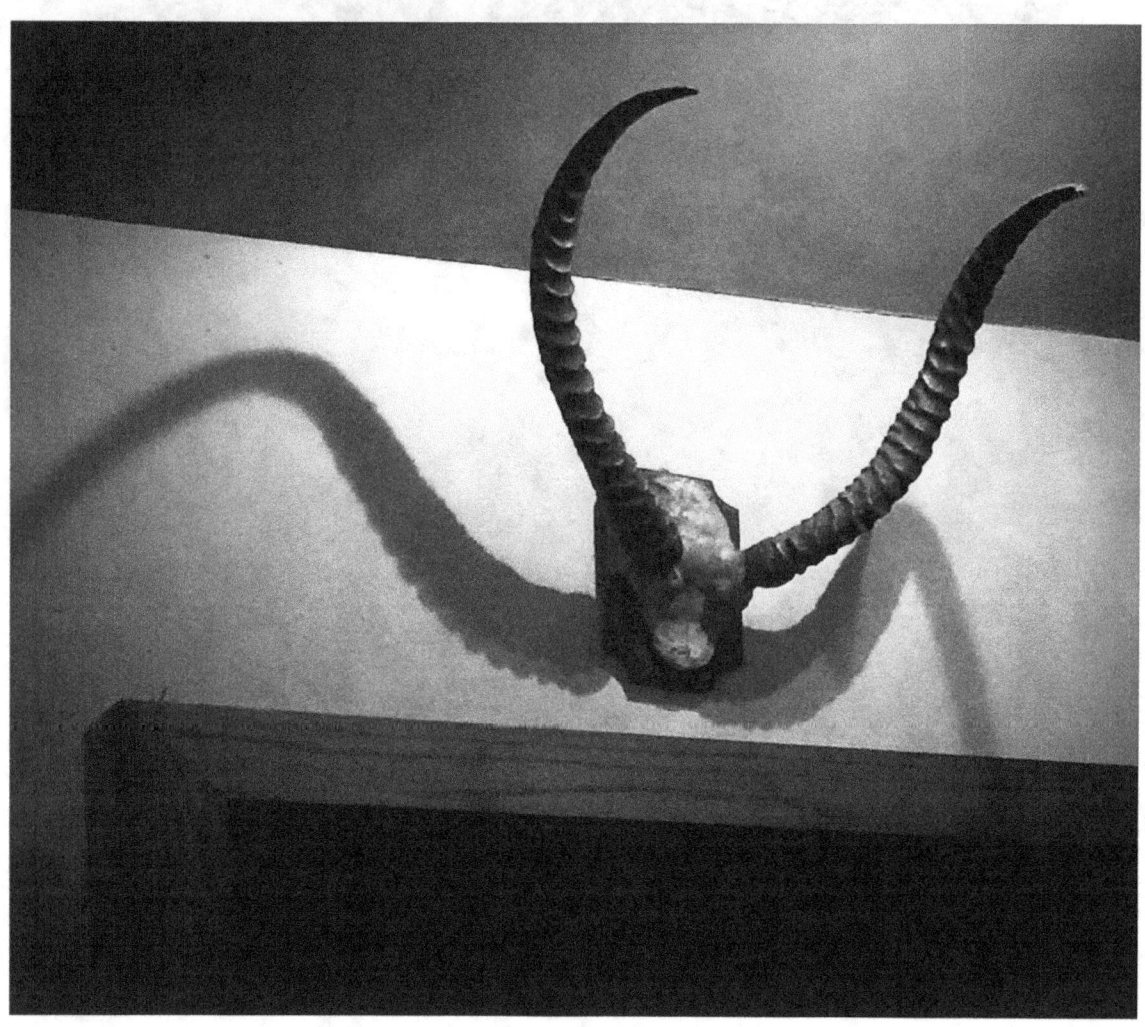

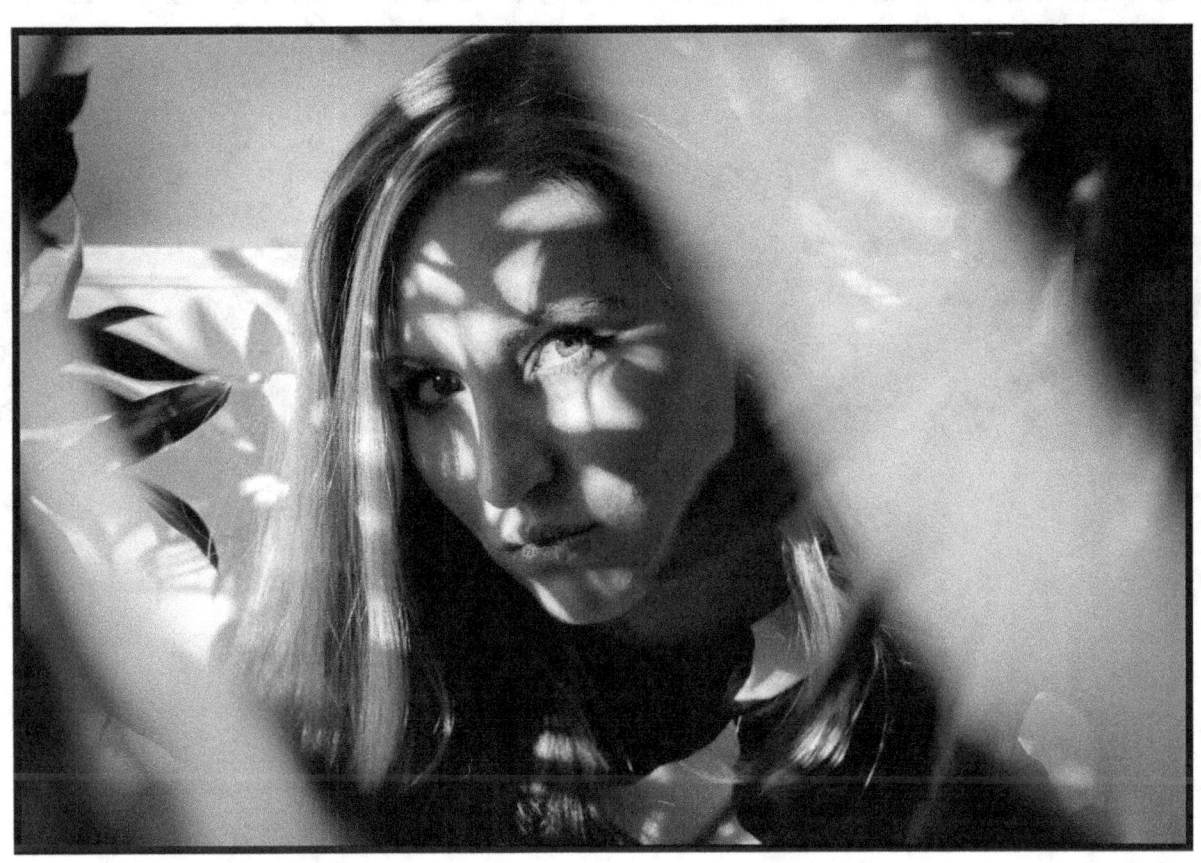

At my smile, she smiled. I was a freak in a darkened carnival tent.
She knew I couldn't be real but she paid her quarter and took her peek.

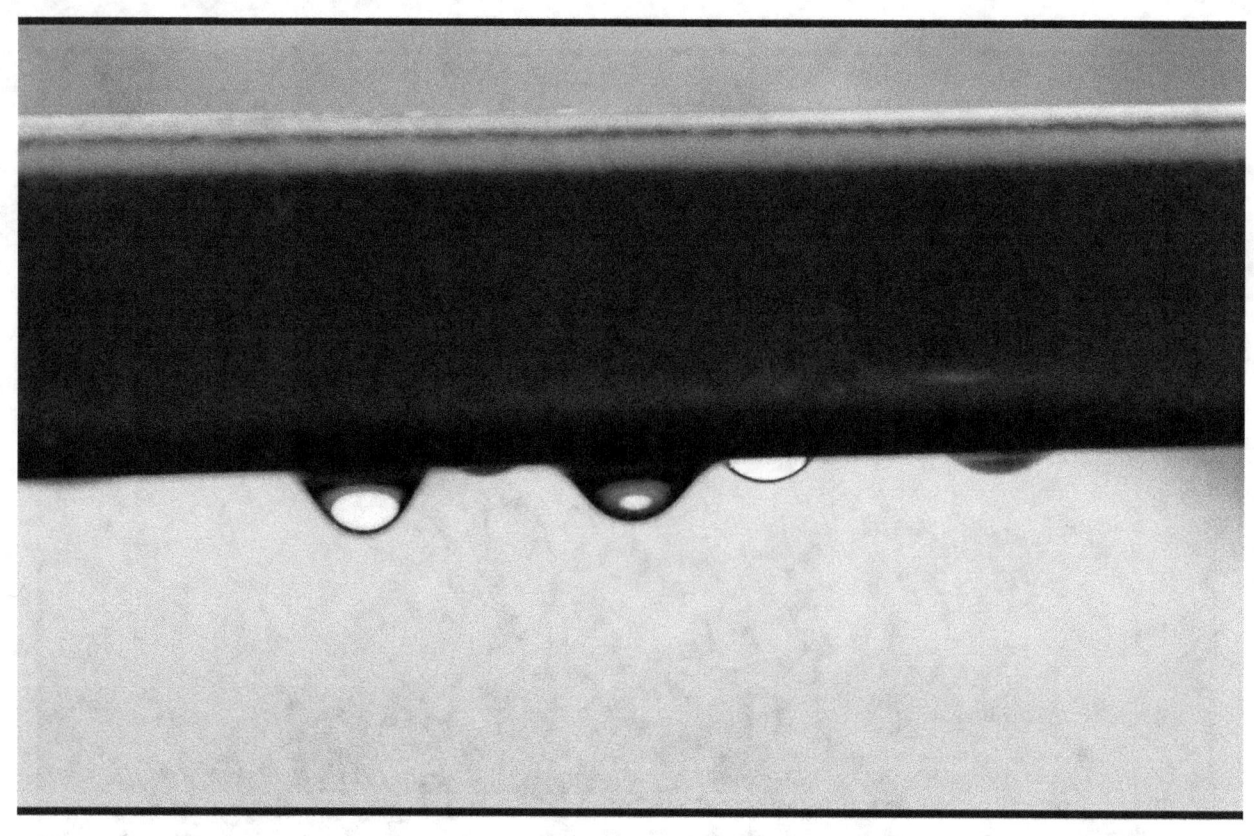

Things are always doing that.

Changing without giving notice.

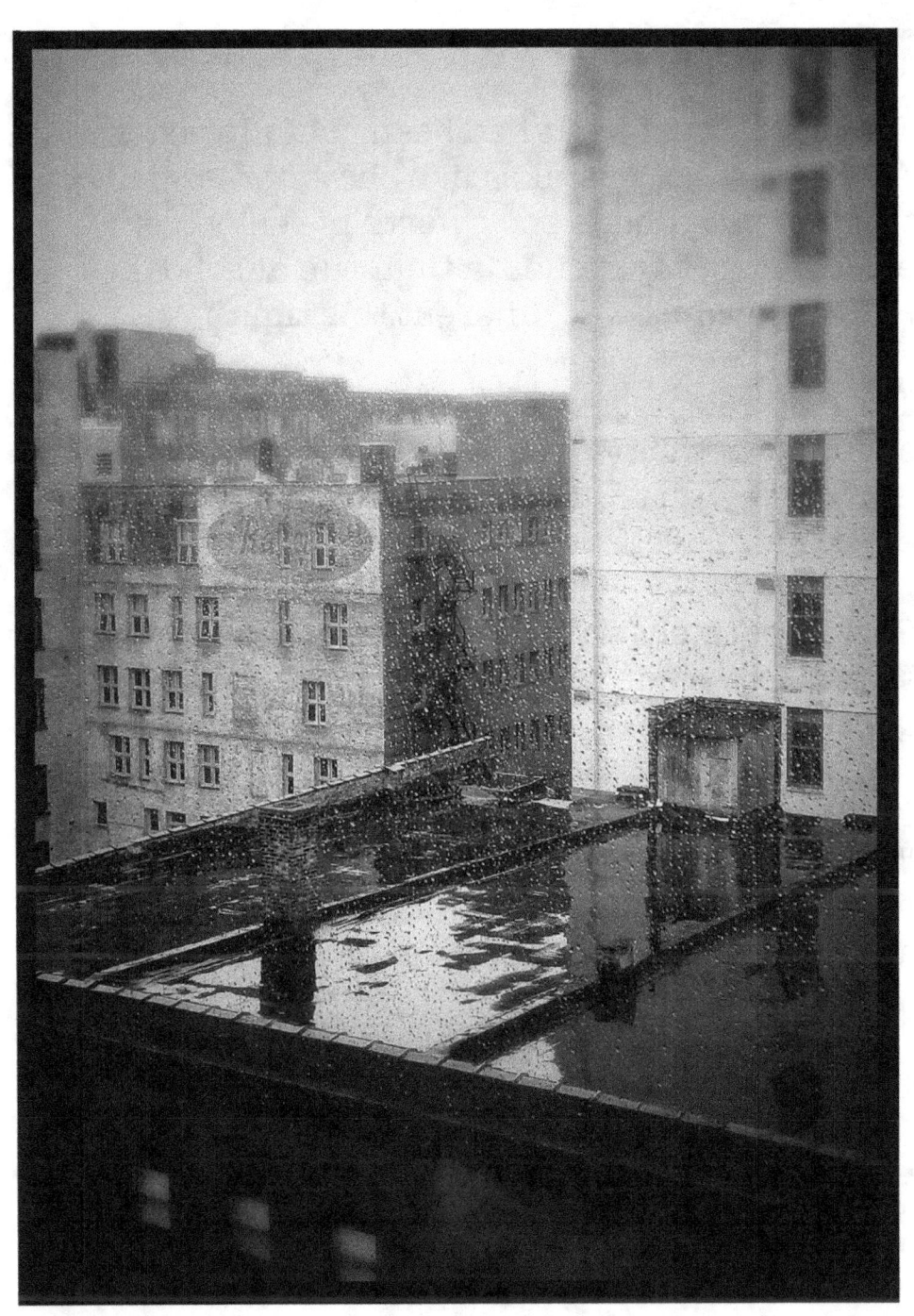

Two hours went by. It had been ruefully pedestrian.
A litany of past mistakes like show horses had been
trotted out; a phone book worth of self-esteem
eviscerating boyfriends, a final run at school
(No, seriously it was different this time.)

The only remotely interesting thing she said was
about her father ("everyone thinks alcohol killed
him but it didn't." "No?" "It was retirement.") and
even this felt rehearsed.

She desperately wanted me to engage her on this but
I was a low-grade lawyer and dropped my line of
questioning.

It was more important the alcohol keep flowing,
With each newly ordered round I swear I saw the
light inside her die a little and a different one,
a more instinctual one rise to the surface.

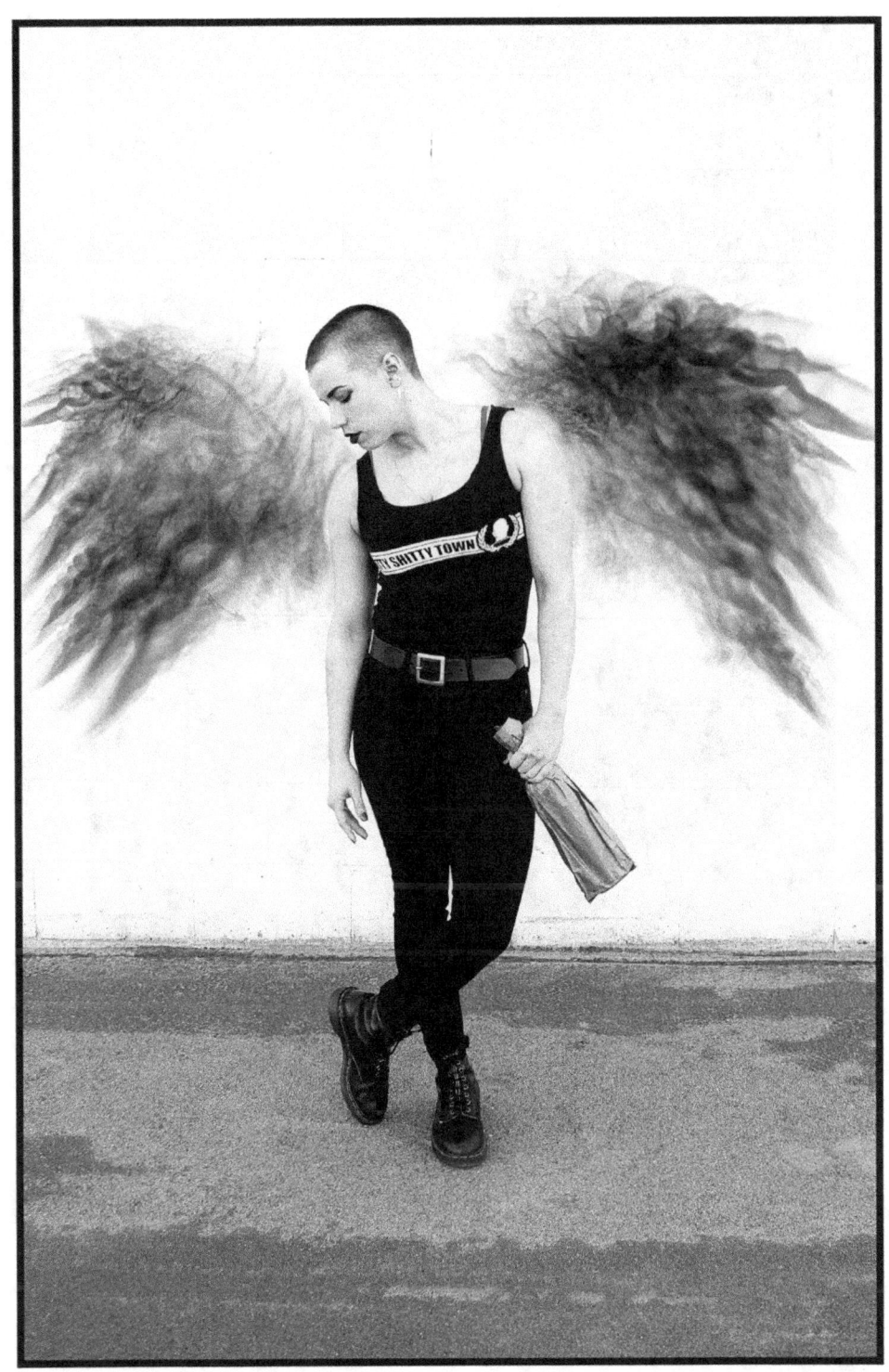

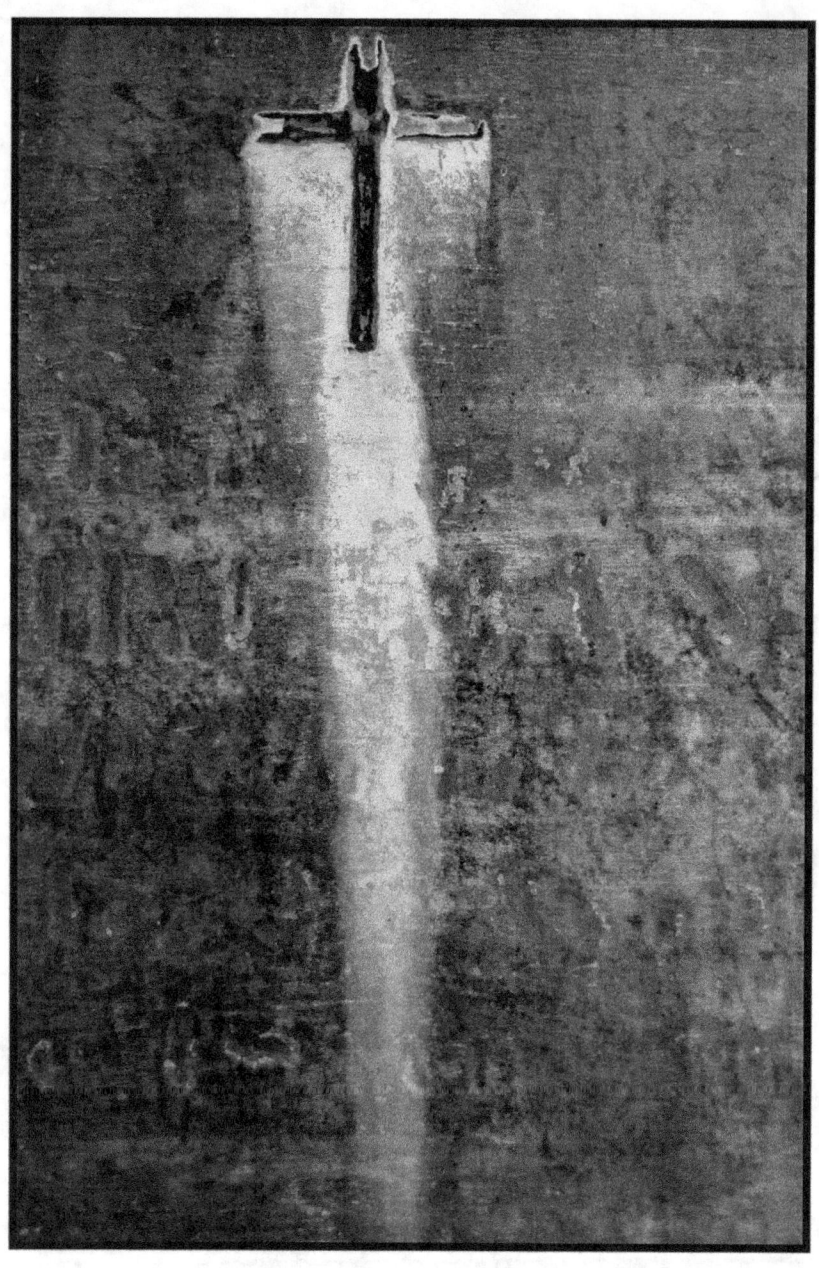

I couldn't remember the last time she had expressed such sentiments to me drunk or sober. Maybe years. I had heard many other things: how we needed to try, how we could recapture what we had lost if we just tried hard enough, drank less, talked more - and hate, there was a lot of that but gladness simple as a sunbeam through a window?

The place was dark, dust swam through a swath of fading sunlight coming through the living room window.

He would be home soon.

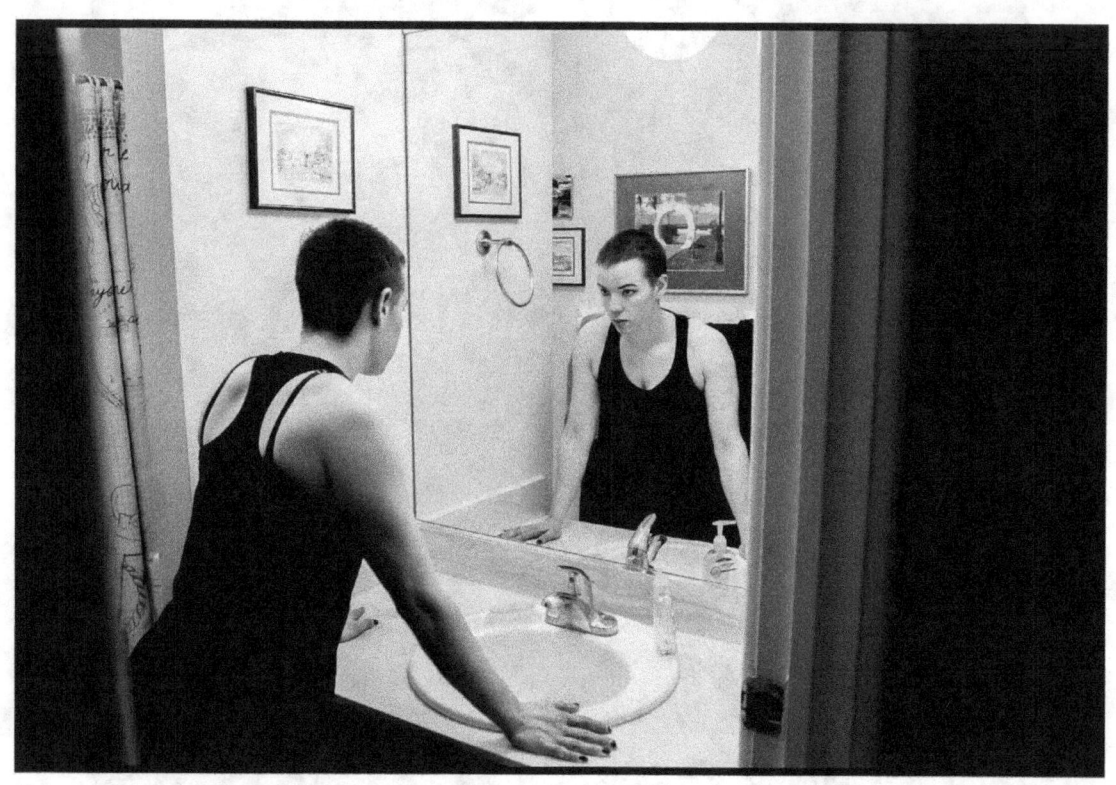

Examining herself in the mirror one bloodshot morning,
as one of them (and they were just that - a mass "them")
lie reflected behind her on the bed she alone had purchased
(with a swelling of pride that brought a chuckle
of tears in the furniture store parking lot)
she concluded, "Pretty but no masterpiece."

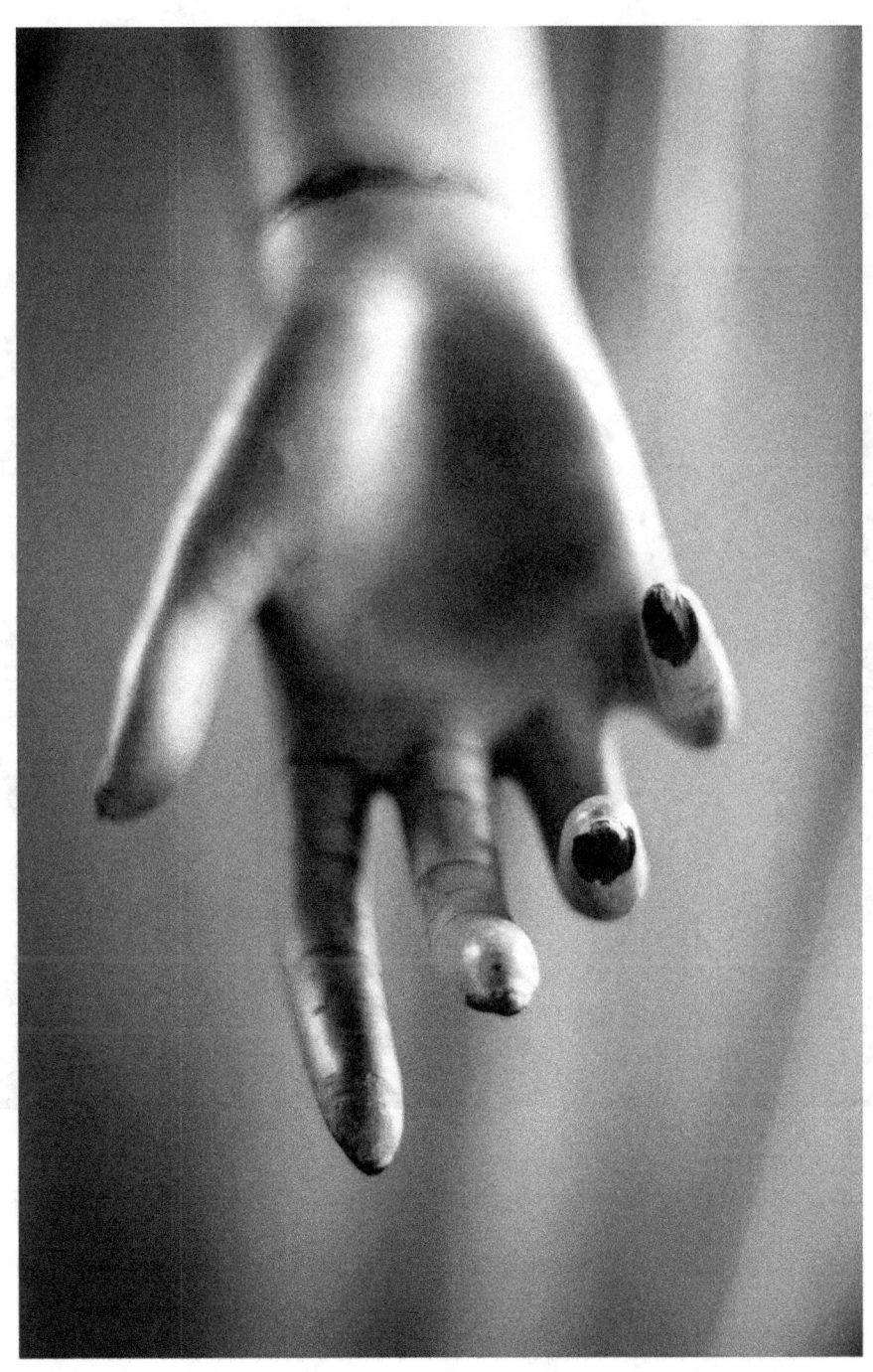
If you're fool enough to buy it you're in for an unpleasant surprise.

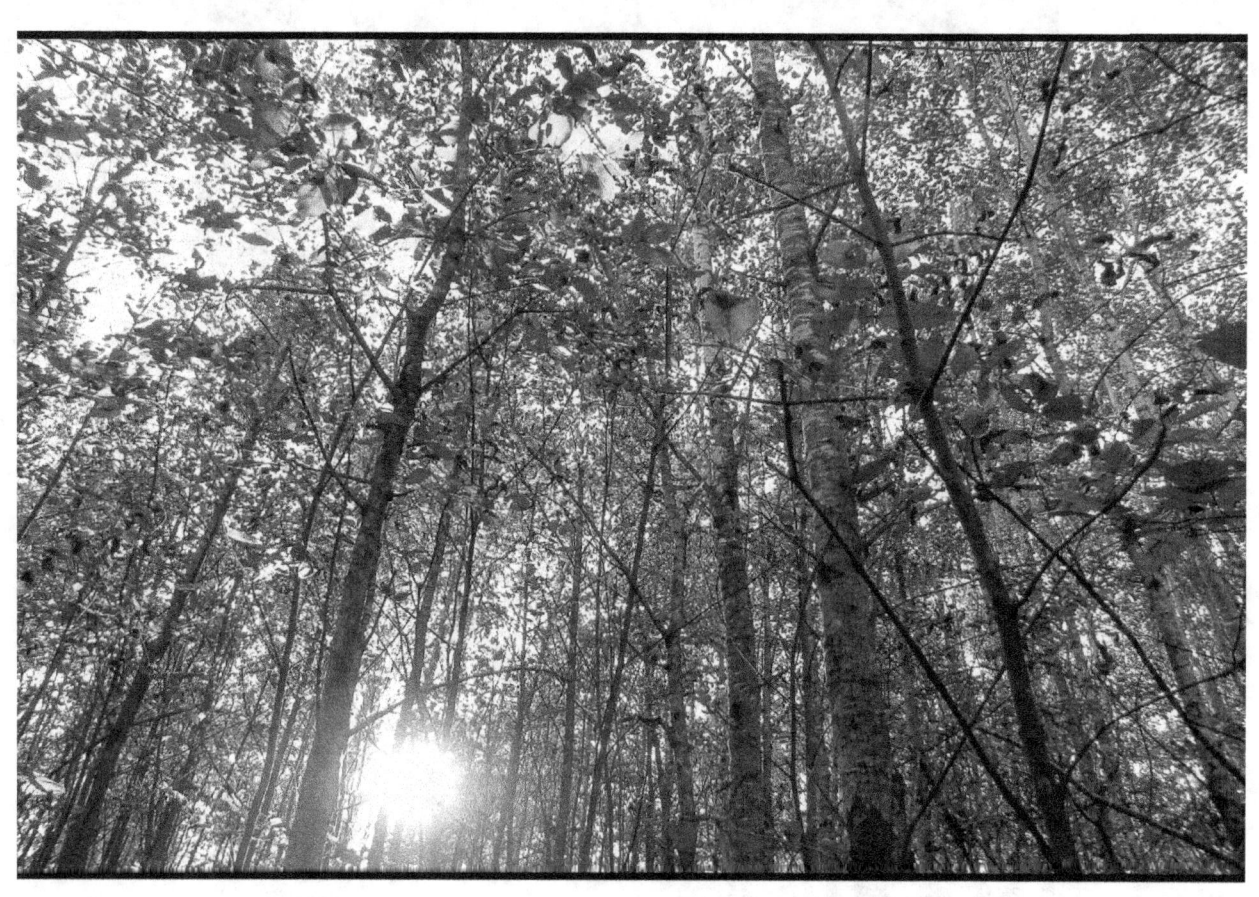

I felt the chains that kept me tied to this earth loosening.

I used to dream a lot after I left, really left.

They weren't specific dreams, just me on a bike or driving at high speeds
or walking along a mountain cliff.
They only thing they had in common was a blinding light,
a piercing light like a loud siren that made it impossible for me to continue on
although I was compelled to.
They weren't nightmares exactly. I never died or crashed into oncoming traffic
or careened off a cliff.

I woke up in a cold sweat.

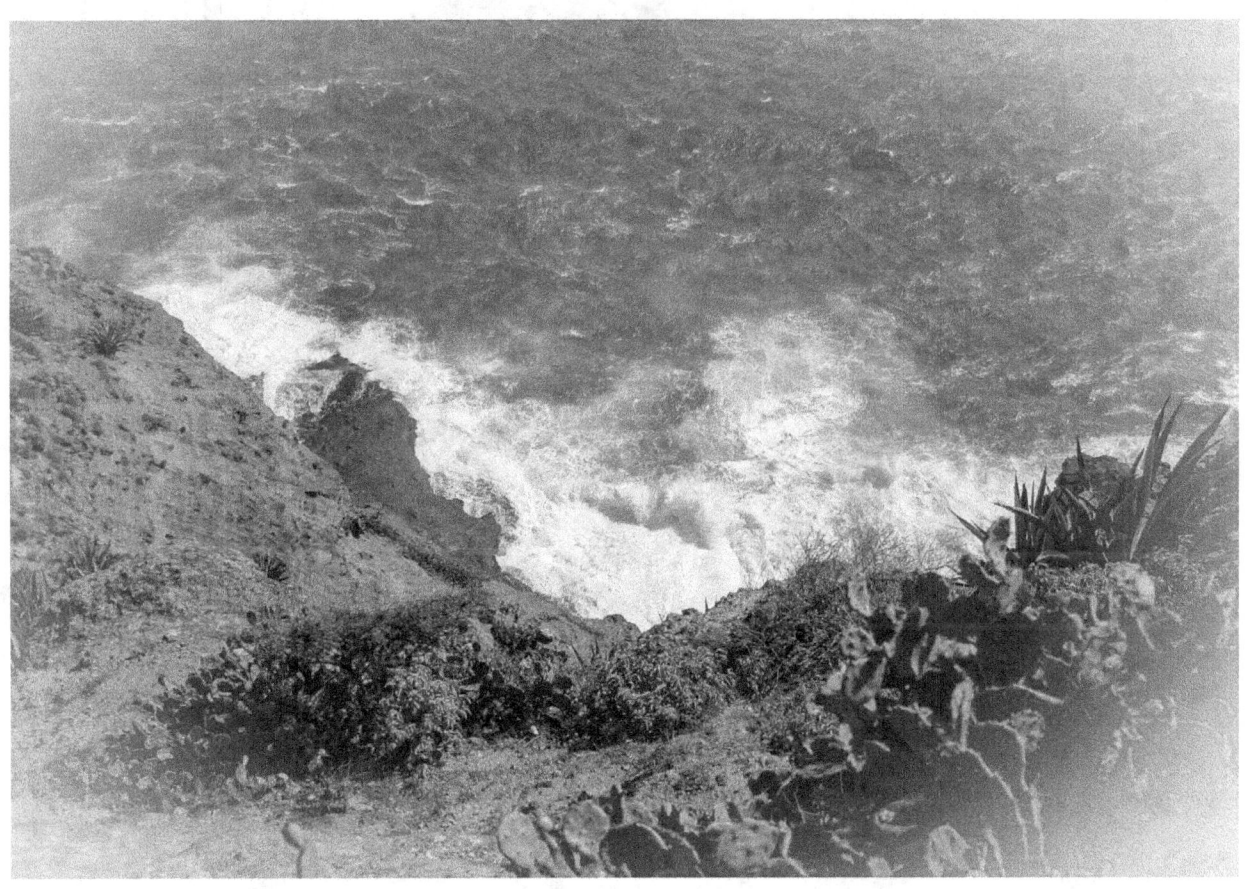

"Silence often becomes the rule.
The shame of their former actions can be an awful
burden to live with, much less revisit."

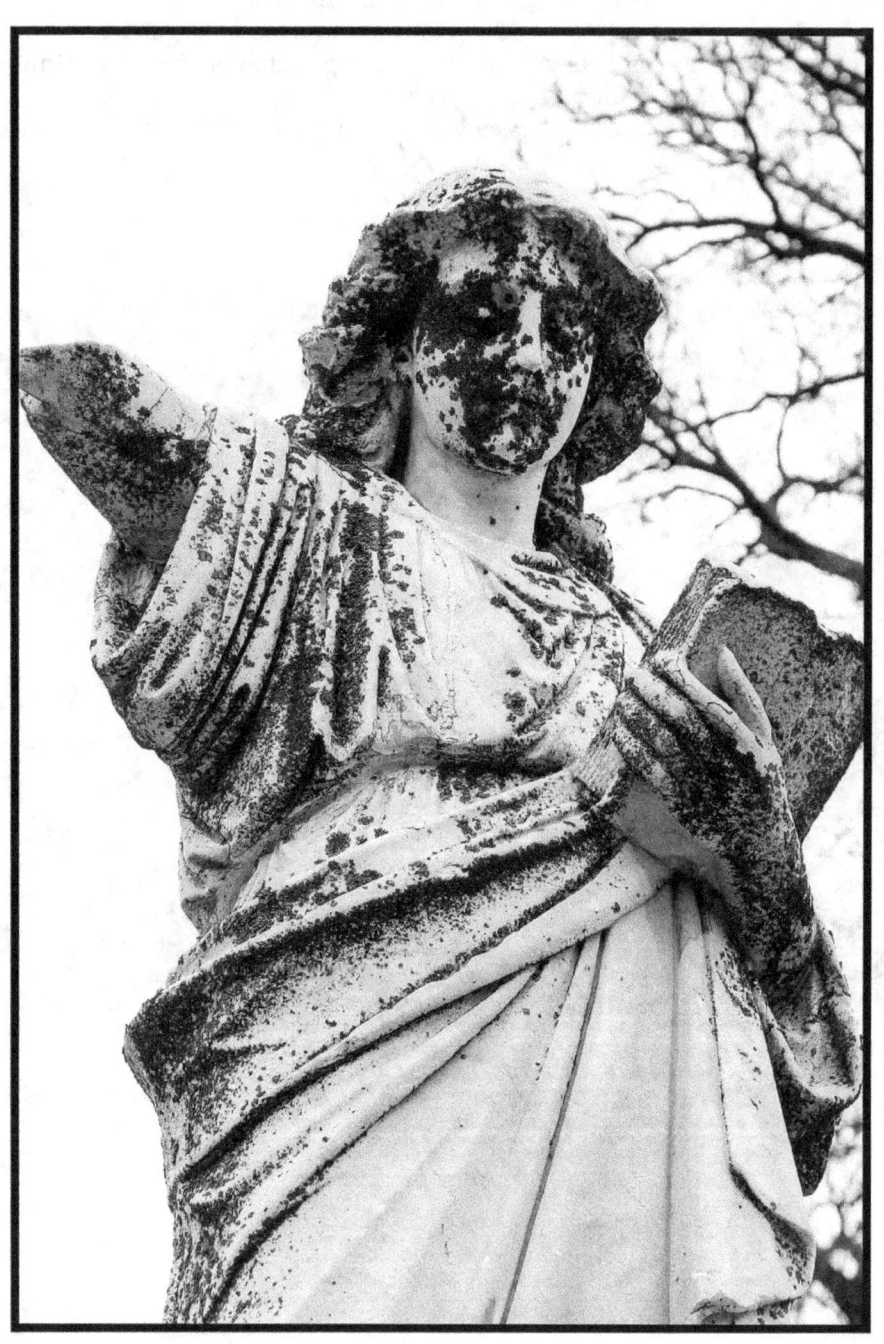

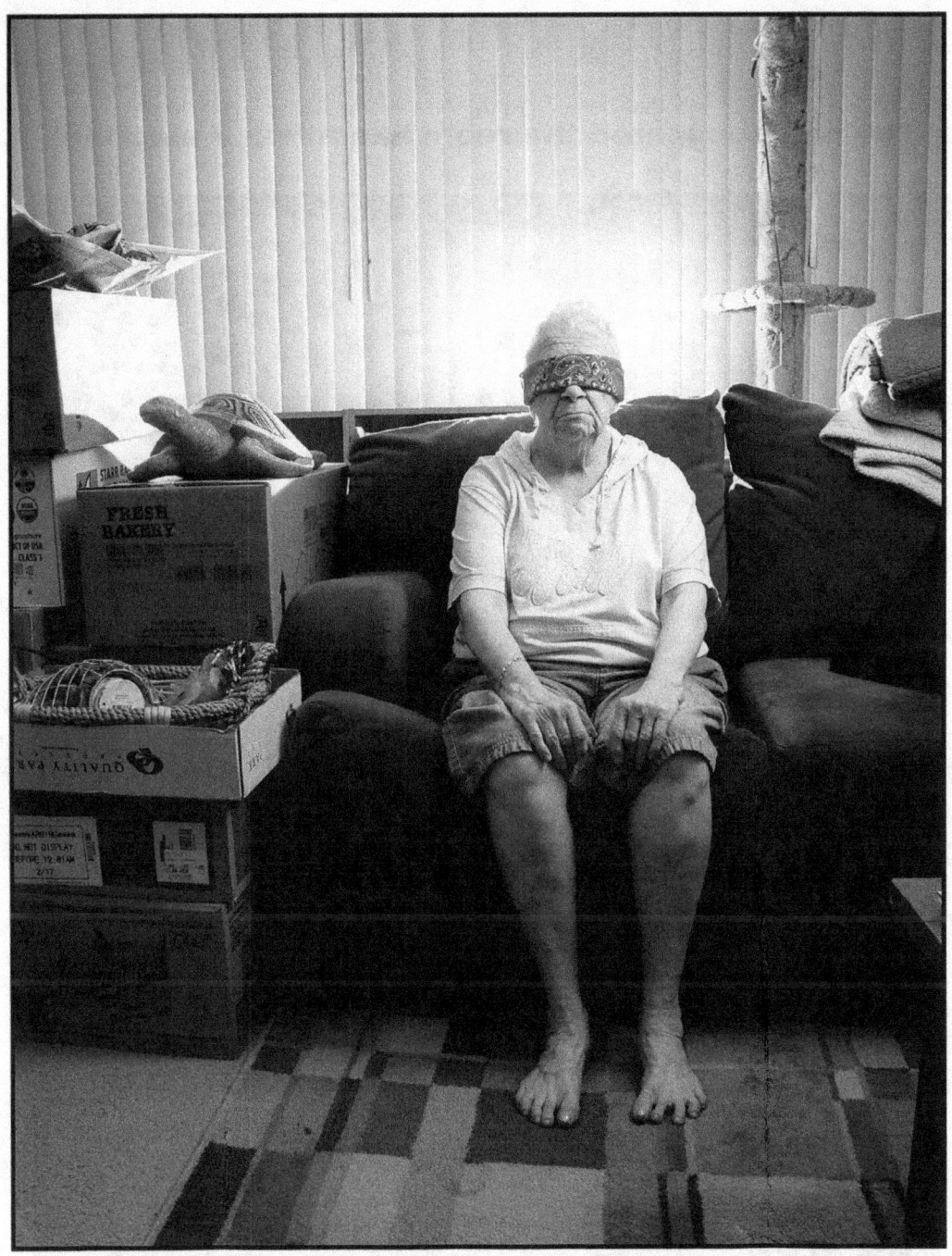

Separating our houseful of things, every knick-knack, piece of furniture and photograph (not to mention the house itself) would be daunting and heartbreaking, a cleaving of our lives.

These bins revealed how difficult the logistics of a divorce would be.

The bed dominated the room like a felled elephant.

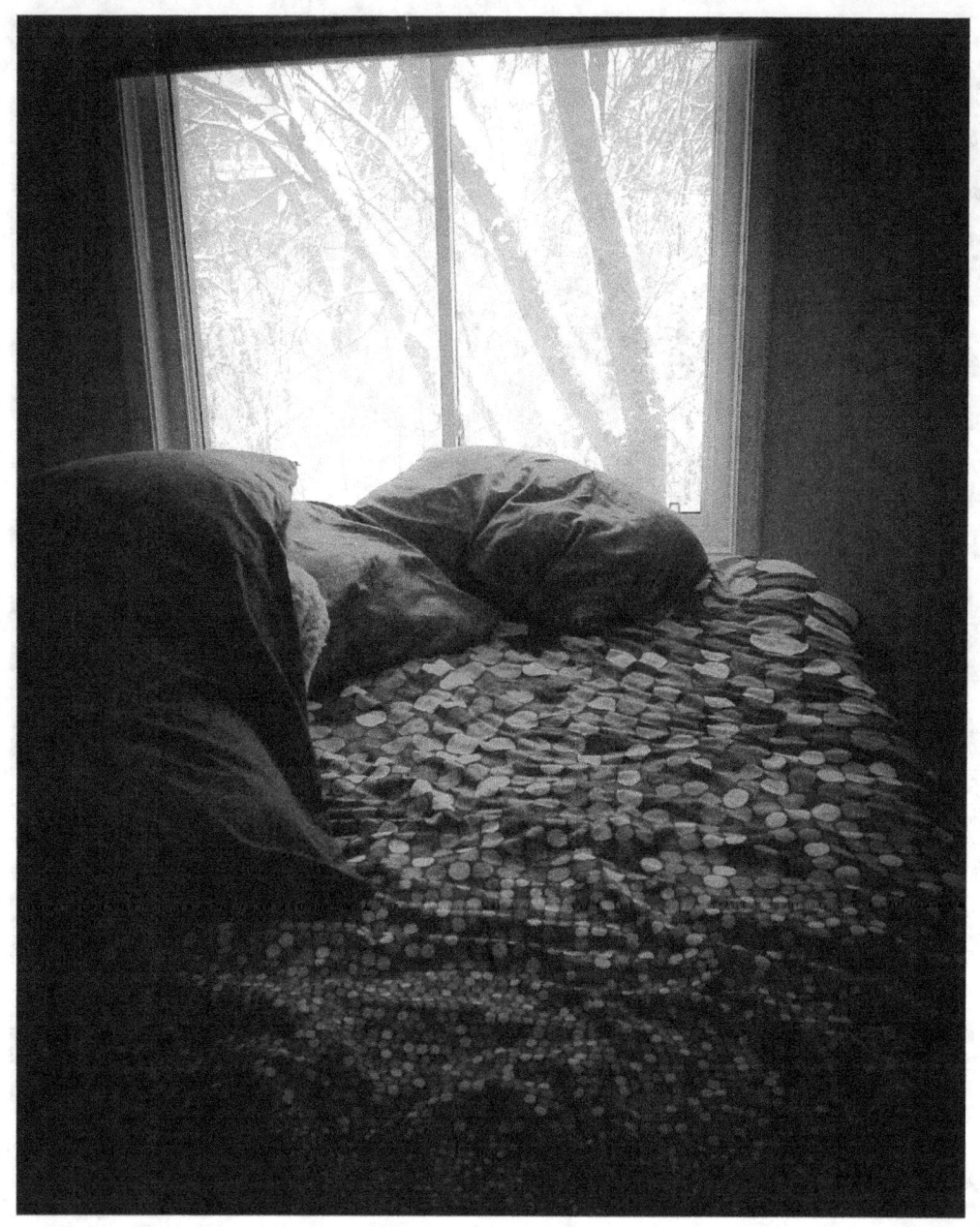

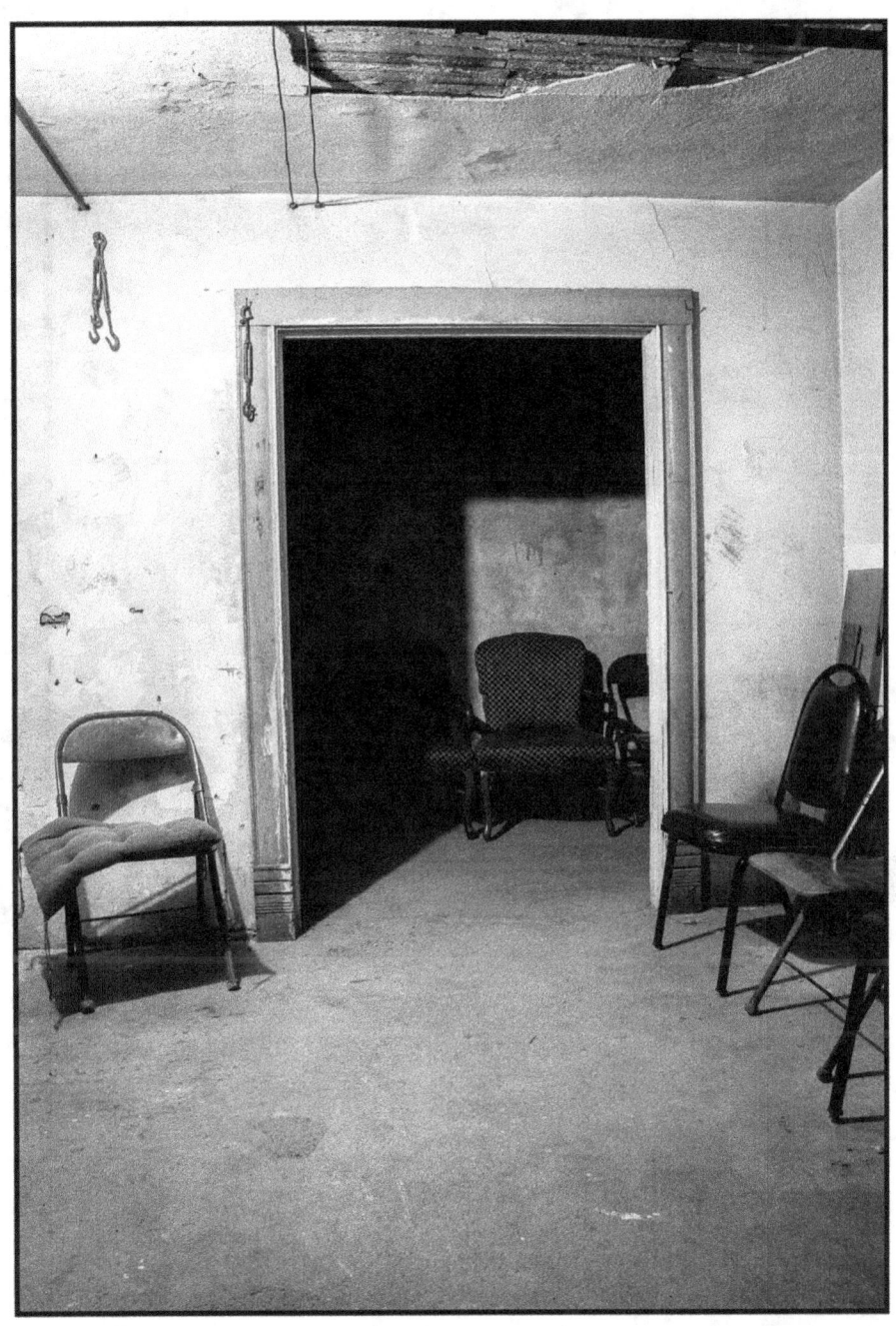

You never think that you could ache for things that are primarily
utilitarian in nature, but why wouldn't you?
They are the crutches you lean on, in some form,
they are part of your life, seen or not, every day.

"I'm like a
depressed shadow
to her bullshit.

a lone, leafless tree
on a high
deserted mountaintop."

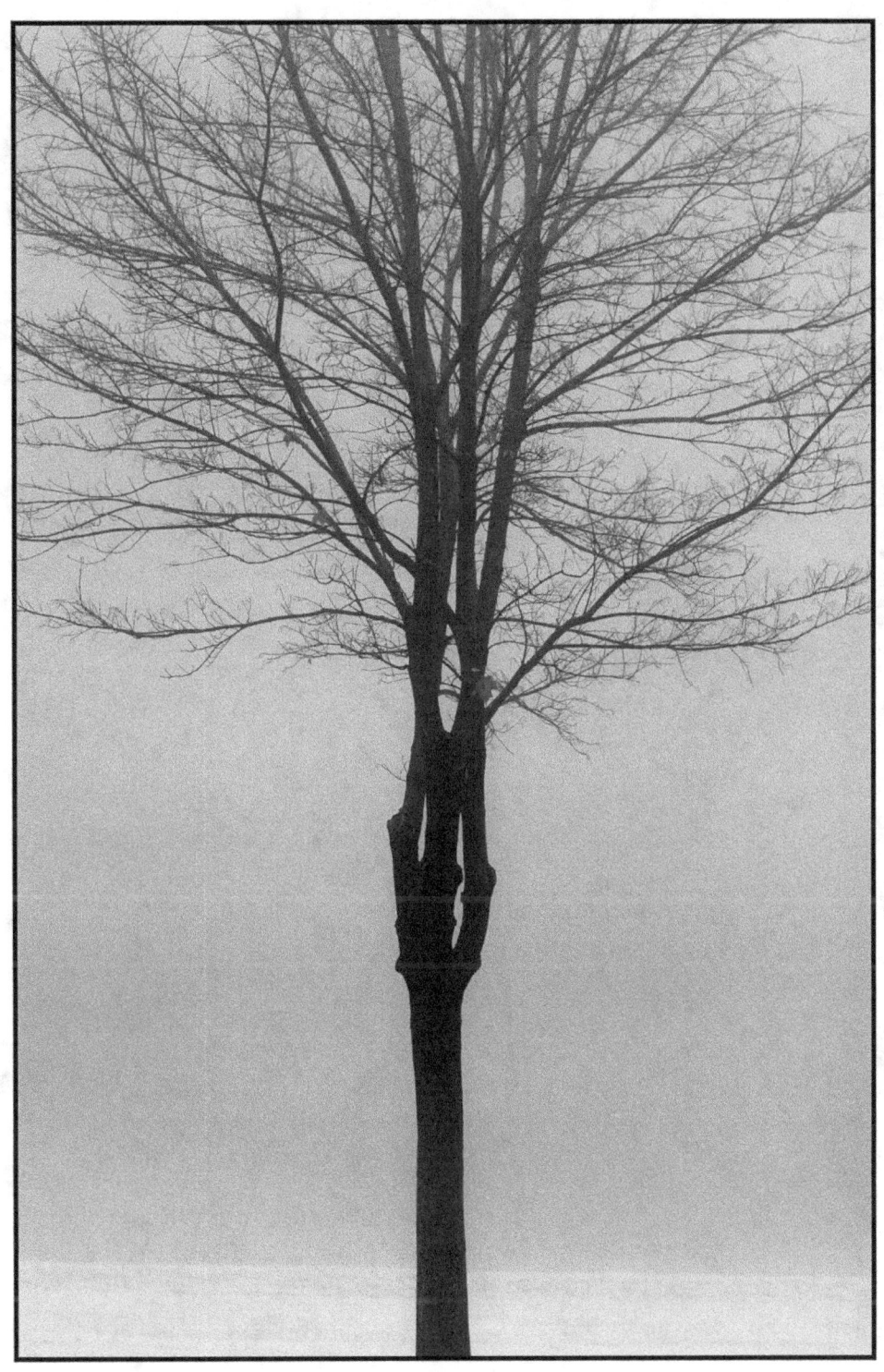

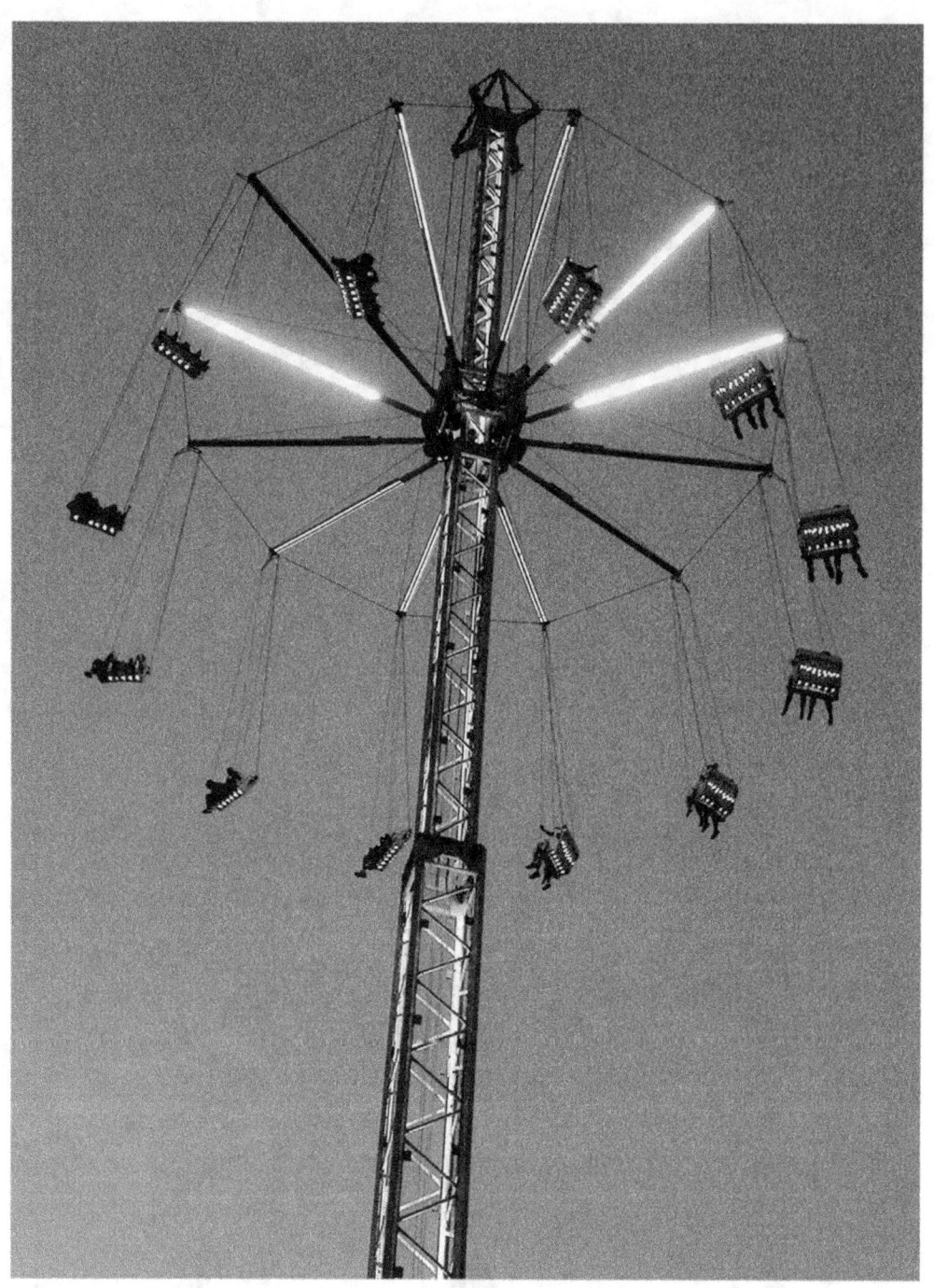
Although her silent offer hung like a lantern hanging from the branch of a tree, I had never claimed it.

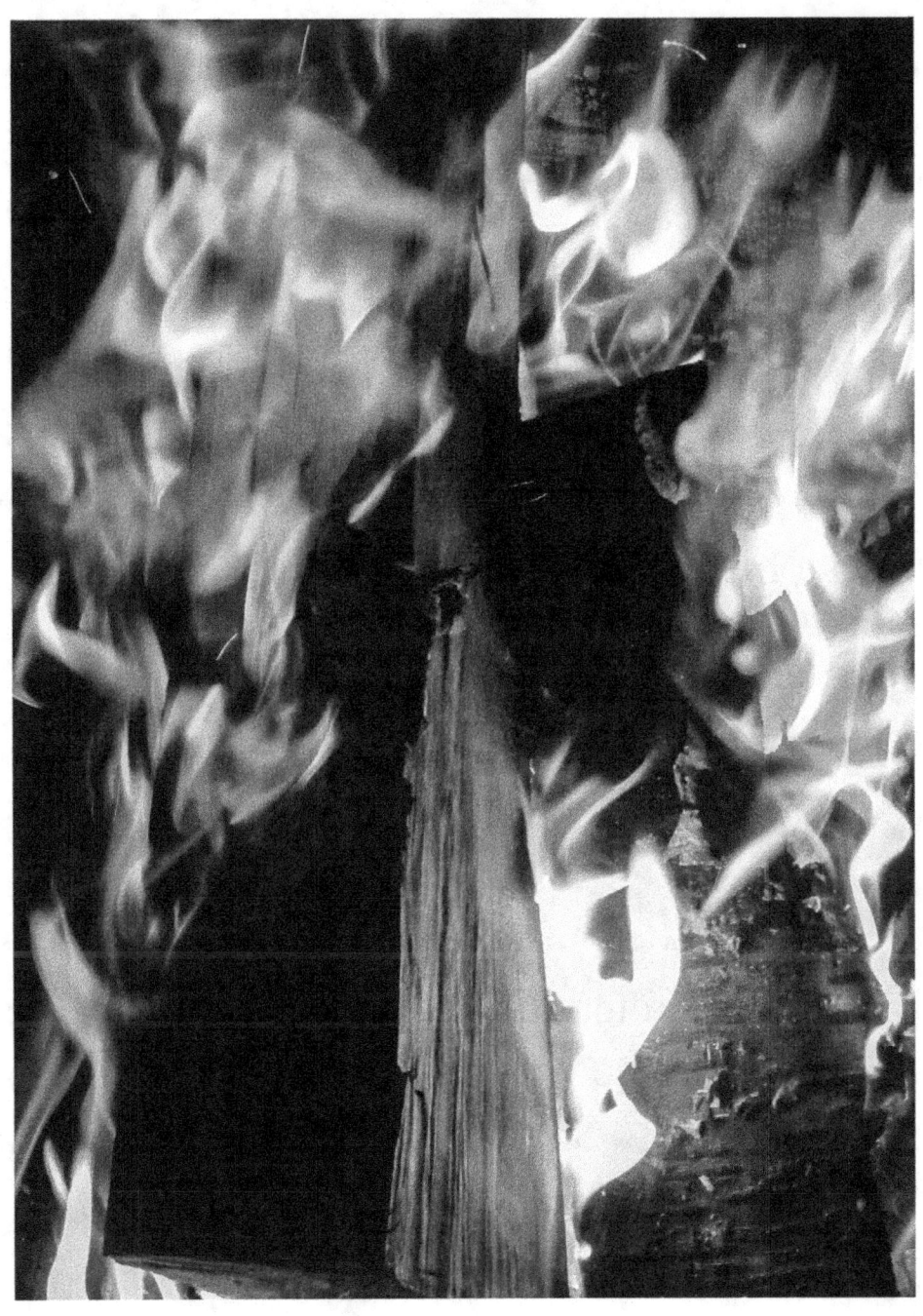

I was tired of burning things down but I couldn't stop on my own, which believe you me was hard to admit.

Life with Katharina was the most
sublime pain I would ever know.

I was astonished not at the heartbreak and suffering
but at the bizzare sweet beauty
like a ripe peach
life still had to offer.

When she used to dance for me
she pretended not to know me,
pretend she wasn't in love with me.

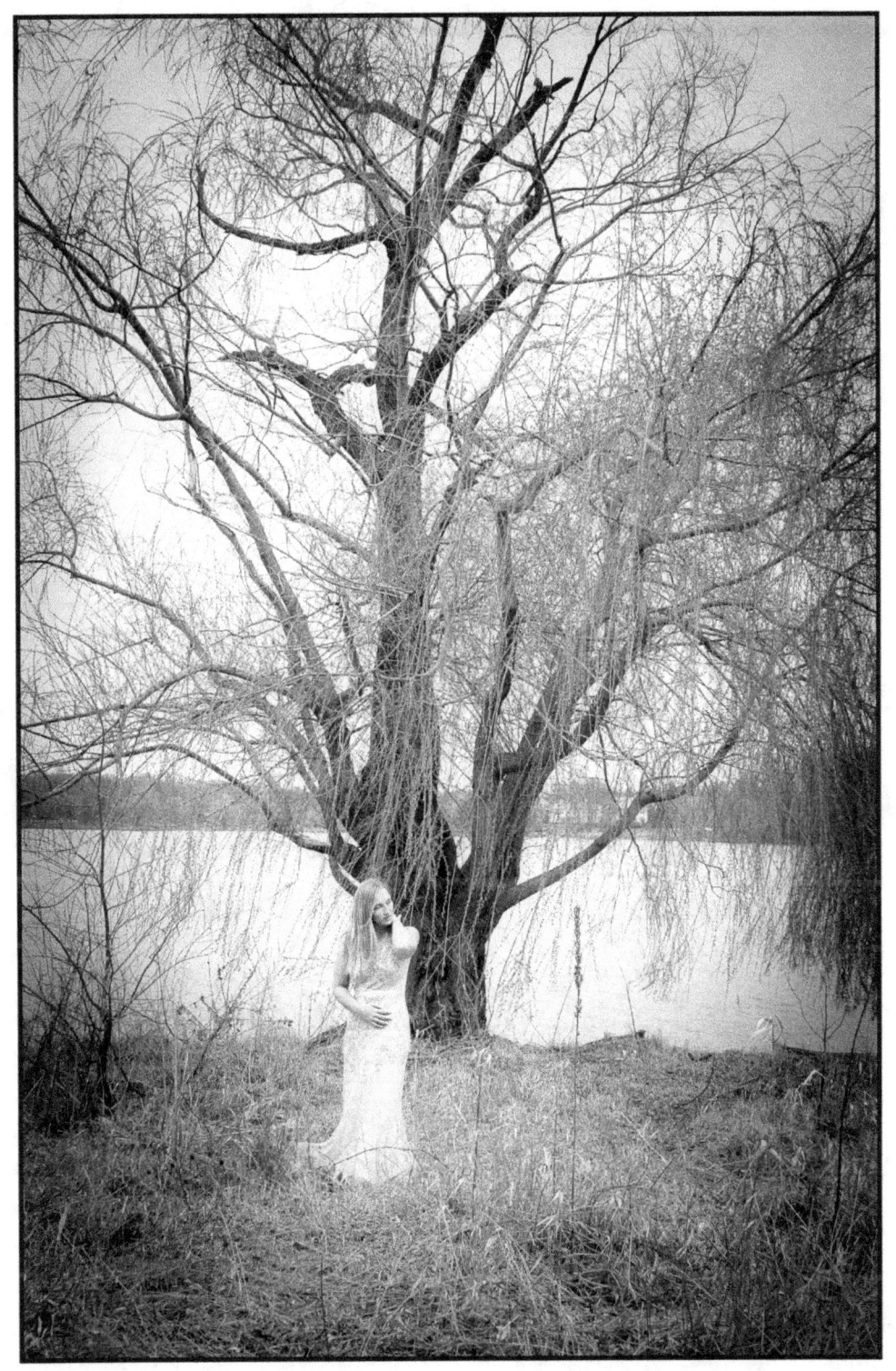

But being so far from home
we had forgotten the horrible people
we had become.

That happens you know.
Through habit and neglect and
casual cruelty and laziness.
Mainly laziness.

But on a long stretch of endless
highway and that one magical song,
it had been sucked out of the window.

It was like the beginning but better,
a resurrection of sorts.
A temporary transfiguration.

It turned out to be our last, pure, sweet,
simple, great memory.

The closing sentence in the novel
of our life together.

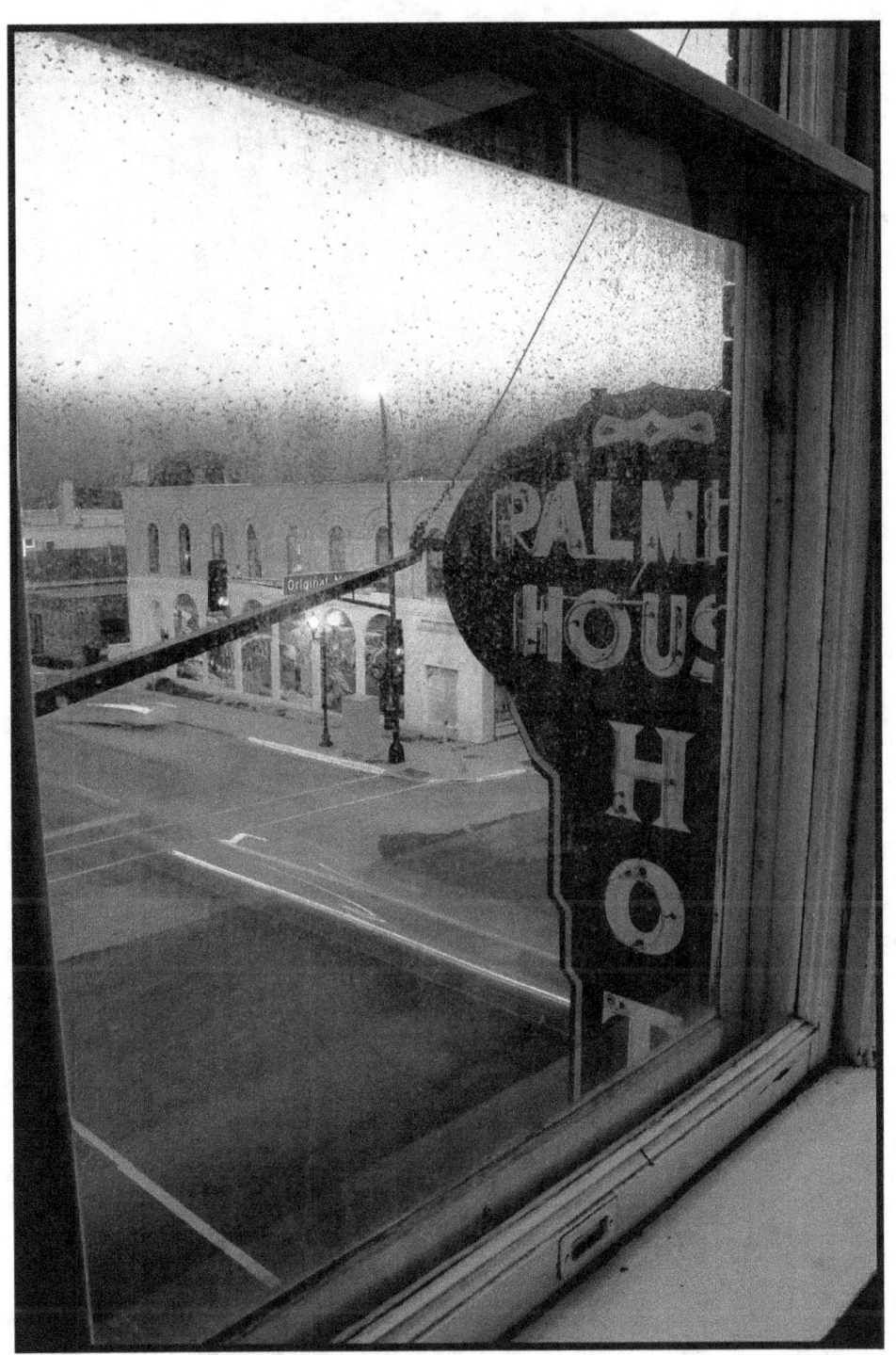

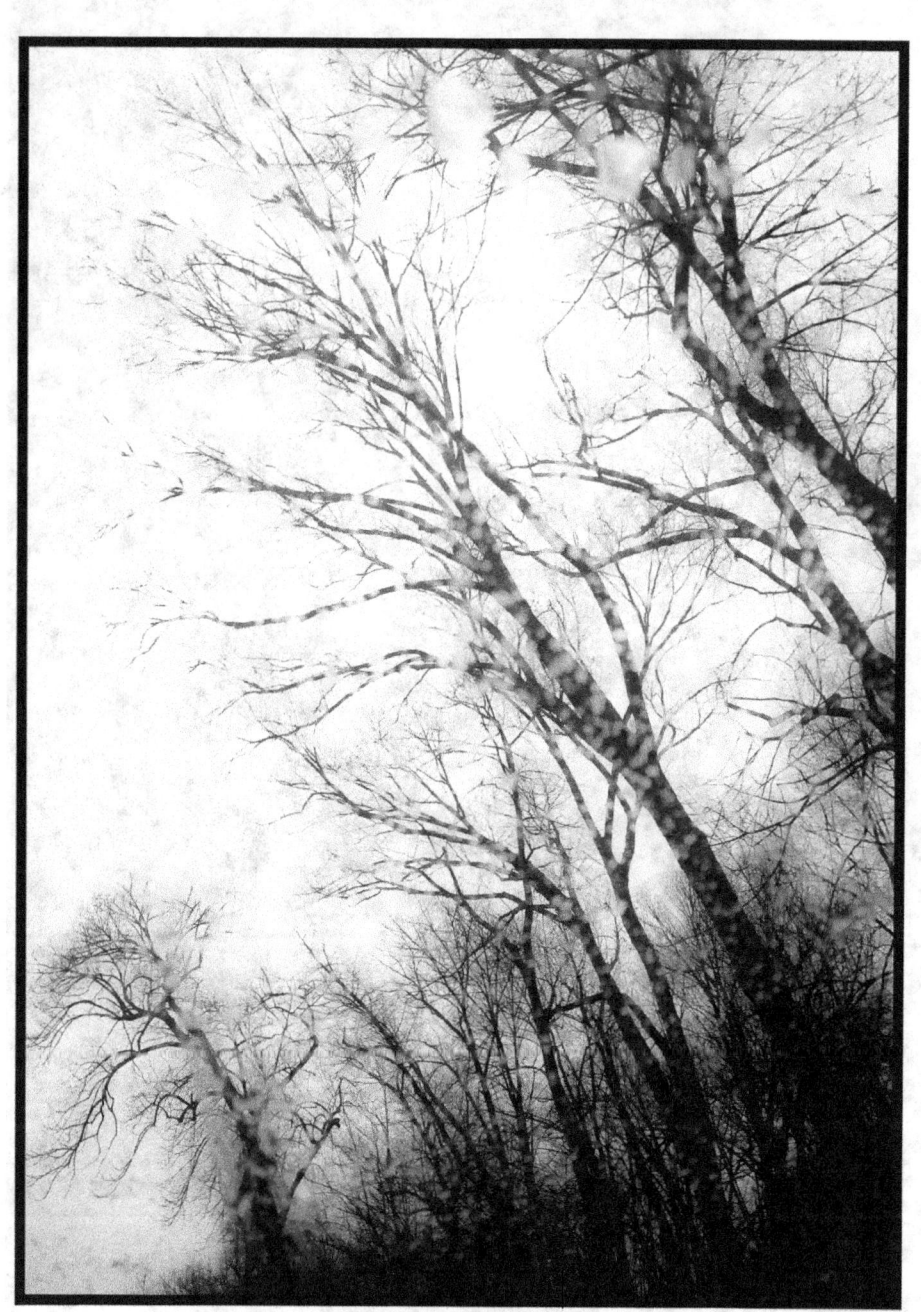

Author Thanks

Jayce:
Special thanks to my parents (Roxi and Ron), David and Gary for the friendship and artistic collaboration, Derek Eaton, Andy Jensen, Lane and Cortney Pederson, Jeremy Stone, Matt Alleva, Aaron and Jodi Lloyd, Tyler Kukowski, Tim Gray, Tom Hanly, Lance Vicknair, The Texas Troublemakers, and big love to my family and friends across the world.

To my beautiful muses - you are truly everything in this mortal coil.

Invaluable thanks to my models on this project:
Johanna Pinckaers, Camille DuBose, Andy Jensen, Rachel Reese, Jake Skovbroten, Chris Kriskovic, Dave Tomko, Ron Legg, Roxi Legg

I also want to thank the photographers who inspire me to make pictures: Henri Cartier-Bresson, John Cohen, Edward Weston, Ansel Adams, Jim Brandenburg, Dan Corrigan, Ross Halfin, and Shelby Lee Adams.

This book is dedicated to the memory and spirit of Lance Vicknair - thank you for helping me see light.

David:
Thank you to Rachel, Carys, Morgan and all the people who have supported me throughout the years

Gary:
Thank you to Adrianne, Max, Vera, family and friends

Special Thanks to the Kickstarter backers for this project:

Lori Shea
Jennifer Starr
Mary McDaniels
Nancy Figueroa
Jody Johnson
Lisa Banwell
Dave Tomko
Emily Vega
Eric Douglas
Christa Seck
Anna Johnson
Rebecca Anderson
Rory Bezecny
Jen Cybert
Susan Martin Robbins
AnnMarie Boorsma
Chris Wachholz
Ryan Shamblee
Marla Wach
Laura Leavy
Joseph Erickson
Jim Portesan
Jeremy & Chrystalle Ball
Elyse Shuldhiess
Mark Panozzo
Stacey Cohen White
John Chole
Niki Marinis

Rachel Raymond
Andrew O'Neal
Jennifer Sampson
Rachel Reese
Natalie Louise Johnson
Maren Longfellow
Andy Jensen
Jessica McCabe
Amy Norberg
Mary Haight
Ronica Kirwin
Sue Haight
Jessica Gordon
Robert Davis
Tom MacNiven
Jeff Conway Hinton
Barbara Zimmerman
Charlette Stepp
Donny Russell
Ramona Ramazani
Jean Marie Gibson
Andrea Impastato Williams
Mark Williams
Kathleen Kramer
Karen Wilkerson
Andy Dillard
Mike Skakel
David Gould
Willie

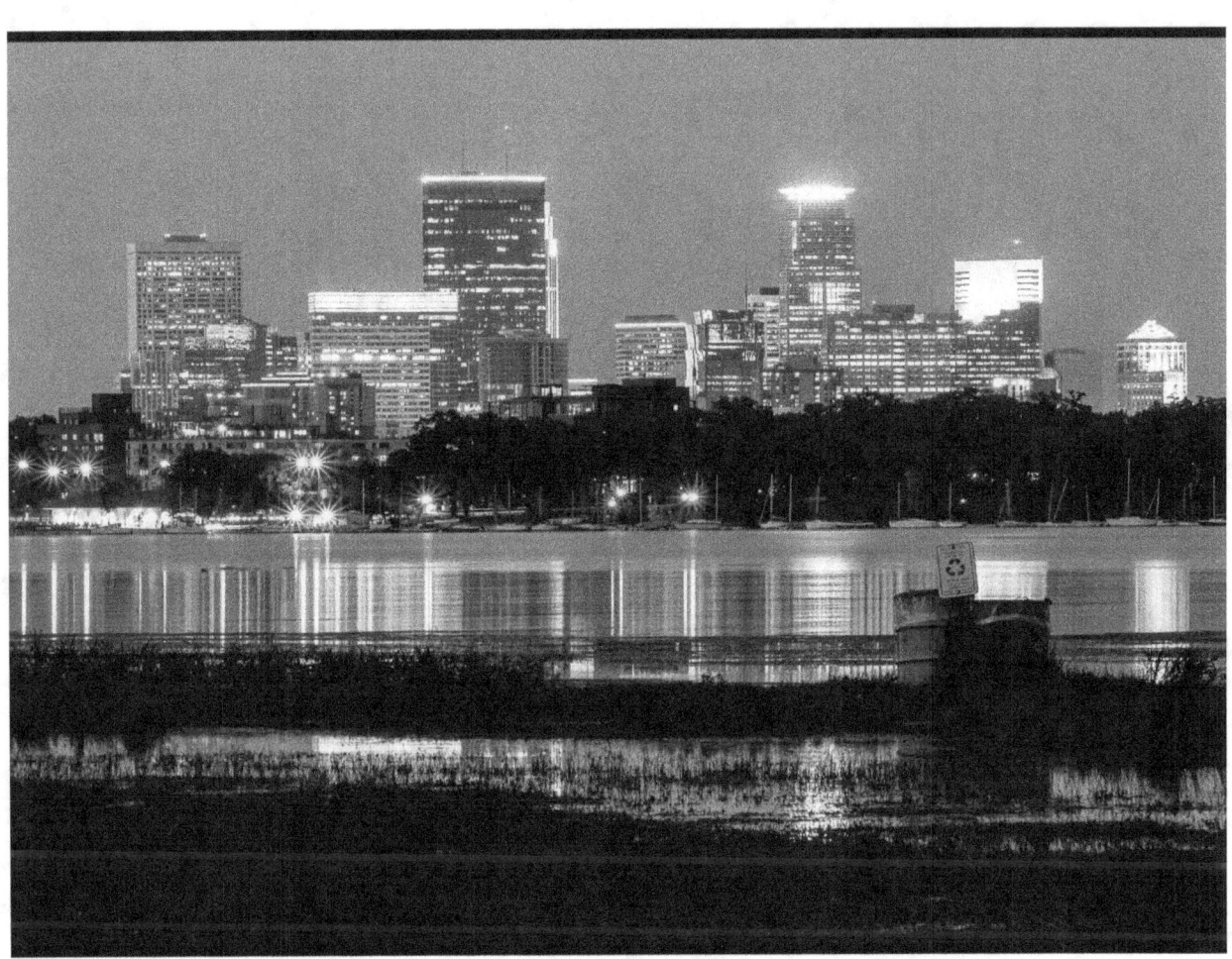

www.ingramcontent.com/pod-product-compliance
Lightning Source LLC
Chambersburg PA
CBHW081252180526
45170CB00007B/2390